Magnificent Failure

Magnificent Failure

A Portrait of the Western Homestead Era

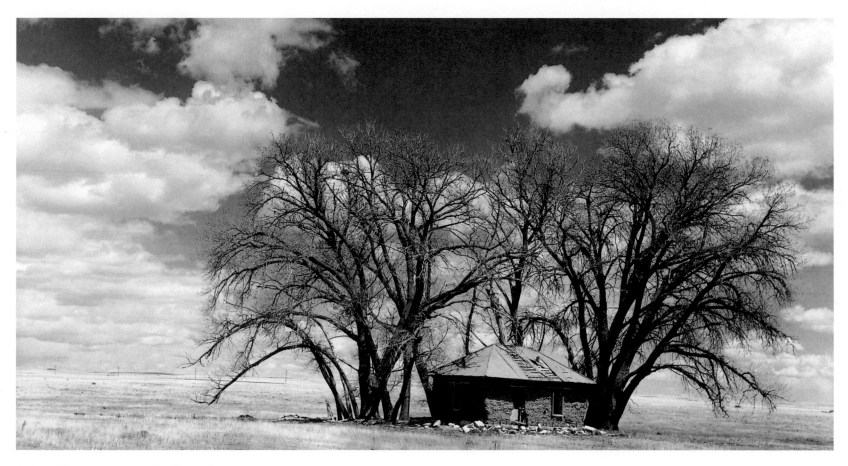

John Martin Campbell *with an Introduction by Kenneth W. Karsmizki*

STANFORD UNIVERSITY PRESS, STANFORD, CALIFORNIA

Stanford University Press
Stanford, California

Printed in China
On acid-free, archival-quality paper

Library of Congress Cataloging-in-Publication Data

Campbell, John Martin
Magnificent failure : a portrait of the Western homestead era /
John Martin Campbell ; with an introduction by Kenneth W. Karsmizki
 p. cm.
 Includes bibliographical references.
 ISBN 0-8047-3886-6 (alk. paper) — ISBN 0-8047-3887-4 (pbk. : alk. paper)
 1. Frontier and pioneer life—West (U.S.) 2. Frontier and pioneer life—
West (U.S.)—Pictorial works. 3. Farm life—West (U.S.) 4. Farm life—
West (U.S.)—Pictorial works. 5. Ranch life—West (U.S.) 6. Ranch life—
West (U.S.)—Pictorial works. 7. Pioneers—West (U.S.)—Biography.
8. Oral History. 9. West (U.S.)—History—1890–1945. 10. West (U.S.)—
Pictorial works. I. Title.
F596 .C238 2002
978'.02—dc21 2001042610

Original Printing 2001
Last figure below indicates year of this printing:
10 09 08 07 06 05 04 03 02 01

Designed by Eleanor Mennick
Typeset by James P. Brommer in Sabon 10/14 and 11/16

For

Doris Campbell Campbell and Marjorie Kilberg Shea

Contents

Union County, New Mexico, contains 3,817 square miles, most all of which is prairie, and which together with the prairies of neighboring counties, both in New Mexico and Colorado, compose the southwesternmost reach of the Great Plains. Unlike the more eastern parts of the plains, which before the advent of the Corn Belt were covered with tall grass, this southwestern sector is known as *shortgrass prairie*, a distinction whose importance to this essay will become clear in the following chapters. Today in the Corn Belt, surviving tracts of native tall grass are nearly as rare as hen's teeth, but this shortgrass reach—a classic steppe—remains quite like it was in the days of the buffalo (Plate 1).

Dominated by blue grama (*Bouteloua gracilis*), one of several of the so-called buffalo grasses, practically all of it is owned by cattle outfits—some of whose spreads contain hundreds of square miles—and is grazed by white-faced cattle and impressive numbers of pronghorn antelope (in this and adjoining Colfax County, the New Mexico game and fish people recently counted 15,000 pronghorns). So if you take the dirt and gravel county roads, you will be entertained, according to your interests, by cows, cowboys, pronghorns, and, in season, by nesting larks and curlews. It is quite remarkable, our being able to experience so easily this big relict of western prairie. More remarkable still is that, in fact, it is not a relict at all, but instead is a replica of

what it used to be. Because as it turns out, eighty and ninety years ago most of it was thriving homestead farmland. From the air, it would have looked like an orderly patchwork quilt, its rectangular patches, according to the nature of their crops and season of the year, being various shades of domestic green, yellow, and brown. And these lost farms, together with their analogues across the homestead West, are what this book is about.

Taking up photography as a hobby in 1986, I bought an antique large-format view camera with the hardly original idea of taking pictures of western landscapes. Eleven years later, that venture resulted in an essay on the North American desert (Campbell 1997a). Meanwhile, in my wanderings, I had found an abandoned one-room school standing in the middle of a 20,000-acre cow pasture on Union County's steppe. Designed and built, as I was to learn, by farmers untutored in the practice of architecture, it was elegant nevertheless, and after finding another similar derelict, I left the desert essay on the back burner while I went looking for abandoned prairie schools. My principal reason, then and now, was that they lent themselves so well to what is known as *art photography*. Eventually, however, with transmutations, what began as a study in architectural form became *The Prairie Schoolhouse* (Campbell 1996). That book has to do with getting an eighth-grade education in the days of what

I call the Western Homestead Era, a period that spanned the years from about 1885 to the middle decades of the twentieth century (see Campbell 1996, 2, 3).

This present essay expands the scope of *The Prairie Schoolhouse*. When in 1991 I began work on that project, I found, in addition to derelict schools scattered over millions of acres of deserted farmlands, other homestead relics, the most noticeable of which were abandoned houses and barns. Given the somewhat narrow objective of the schoolhouse book, I ignored for the most part those other artifacts, but as the schoolhouse studies grew to span three years and parts of twelve western states, I came to realize the potential value of a more holistic pictorial, one whose photographs and narrative would relate to a broader spectrum of homestead endeavors.

For one thing, no such book existed, and for another, as I observed frequently, homestead architecture and other portable homestead artifacts suffer these days from an extraordinary rate of attrition. Further, as the schoolhouse project evolved, and primarily because of my newly acquired friendships with western era survivors—homesteaders and their descendants—I learned to appreciate some of the less obvious dimensions of their enterprise. Hence, the contents and title of the present essay.

Having composed a mental picture of the sort of book that would best reflect the nature of the era, the tasks of taking photographs and collecting auxiliary data were initially matters of returning to my "schoolhouse" haunts and friends. From those trips I extended my fieldwork into homestead regions new to me, driving through the old farmlands and keeping an eye peeled for suitable photographic subjects. Once I found the more obvious of them—deserted buildings or abandoned machinery—I tracked down their present owners, both for permission to take pictures and to inquire after the history of local farming or ranching. Typically, the owners, often domiciled miles from the ruins in question, were the kinds of people noted above, either surviving homesteaders themselves, or related closely to the original farmers, and always they took a friendly interest in my work. Further, they encouraged me to photograph a variety of smaller relics, often carefully kept souvenirs of their families' homestead days, of the kind shown in Plates 6 and 43.

As the work evolved, the accumulating evidence suggested more specific literary objectives: a summary of the history of homesteading in the United States, descriptions of motive and process in developing western homestead farms, and explanations of the natural and social agents that shaped the rise and fall of the era. The Introduction and chapters that follow cover those subjects in that sequence.

Some of the essential base data for this essay are derived from the literature; these sources appear in both the text and in the references. But as my field studies progressed, I learned that the testimonies of my informants were of first importance. Although they encompass a variety of professions, most are farmers and ranchers. They remain on the land today, and if most of them did not themselves experience the western homestead era, they are able to recollect in detail the handed-down experiences of their parents and grandparents (see Acknowledgments). Thus, the greater part of this book is based on their individual and collective oral accounts. Finally, the book also contains my own contributions, the result of growing up on a small farm in the sagebrush country of the interior Northwest, where I learned the uses of numerous western era artifacts and first became acquainted with quite a few of the old-time homesteaders, among whom was my father, J. M. Campbell. Purposely, the photographs are confined to images of objects and landscapes—inanimate things. This restriction may derive in part from my being

a professional archaeologist, but be that as it may, deserted farms and their belongings testify in ways that pictures of people and livestock do not.

For those readers and viewers who have an interest in black-and-white photography, the photographs were taken in existing light with a Kodak Crown Graphic view camera on 4×5-inch Kodak Tri-X and T-Max sheet film. Three sizes of lenses, 90mm, 150mm, and 250mm, were used exclusively, with the 150mm lens accounting for most of the images. Aperture settings were f/32 or f/45, and exposure times varied from one-sixteenth of a second to four minutes.

Acknowledgments

Composing a book that is derived principally from field interviews and observations, whose geographical scope encompasses much of the American West, and whose subject is as intricate as that of the western homestead era has required help from dozens of people whose collective knowledge covers a remarkable range of lore. Quite naturally, most of them are farmers or ranchers—an impressive majority of whom are sons and daughters or grandsons and granddaughters of homesteaders, or are otherwise associated closely with the history of the rural West.

I am indebted quite exceptionally to Katherine Kallestad and Marjorie Kilberg Shea, of New Mexico, who have served the project as Chief Archivist and Principal Field Associate, respectively. Equally important has been the invaluable help of the homestead historian Kenneth W. Karsmizki, Associate Curator of History and Historical Archaeology, Museum of The Rockies, Bozeman, Montana. He has not only written the Introduction to this book, but since 1992 has served as my academic adviser on western farming. And there is Van Dorn Hooker, distinguished architect, whose drawings appear in Chapter 3 and whose expert eye has over the years contributed so much to the charm of the University of New Mexico campus in Albuquerque. Others who devoted hours, and indeed days, to furthering my education are Phil Ballard, Colorado; Rebecca Jo Johnston, Verna Lou Landis,

and Arthur D. Miles, Montana; D. Ray Blakeley, Jodie Tillman, and Nancy L. Robertson, New Mexico; Marsha Sweek, Oregon; Gordon L. Gering, Washington; and Peter F. Smith, Wyoming.

The following men and women, farmers and ranchers primarily, but also including agronomists, historians, land surveyors, and meteorologists, among others, contributed less expansive, but nevertheless critically important assistance: Winford Bean, Dan Fernandez, Robert and Barbara Shannon, Philip Tillman, and Paulette Waggoner, Colorado; Melody and Ronald Finley, Kelly and Dalen Kast, Jo Anne Lanham, Georgia Miller, Peggy Orcutt, Beverly A. Soggs, and Wes Whitworth, Idaho; Sky Anderson, Kenneth A. Arthun, Laurence Blattie, Clarence Chadburn, Judy Eisenman, Robert L. Hamm, Doris Hoop, Ely and Gladys Johnson, Walter Johnston, Carolyn Karsmizki, Marc King, Warren P. Latvala, Keith A. Neault, Cliff and Sally Olson, Merton Robertson, Barbara and Ted Scofield, Kristan Swandahl, Mary Swandahl, and Butch Waddell, Montana; Emerson Buckley, Jr., Nebraska; David Anderson, John Berry, Donald M. Campbell, Robert Clay, Loyd H. Davis, David Graham, Elaine and Michael Holt, Katherine J. Liden, Tony Maestas, Jr., Eloy Martinez, Donna O'Dell, Bruce and Mayme Runyan, Victor Scherzinger, James Clay Seanny, Tammy Sproule, Vera Turner, and John White, New Mexico; Edward Anfinson, Herma and

Gordon Axness, David J. Chamberlain, Don Gunlikson, Duane A. Landa, Gary Levang, Dale Moline, Joe Reems, David Sandowsky, and Louella B. Wychoff, North Dakota; Pauline Brayman, Robert L. Campbell, Delmar Clemens, Helen Cowan, Emory Ferguson, C. Gard Fulton, Caroll Hueller, William A. Hueller, and Tami Sneddon, Oregon; Bernice Cundy and Christy Smith, South Dakota; Lois Armstrong, Frank Arnold, Teri Barnett, Stewart Basse, Jeff Brunson, Clinton Cosner, Scott Donbrawsky, Tom Grissum, Clarence Harrell, Walter Ballad Johnston, Albert Lentz, Trudy Lindon, Clyde H. MacIver, Dennis McGraw, Tom J. Mecca, Carol Richards, Karen Robertson, Alan Shippe, Cathy Littlejohn Springer, Sydney Stevens, and Keith Williams, Washington; and Edna and William Barber, Doris Hooks, David Rawhouser, and Nels Smith, Wyoming.

From over the eastern horizon, the contributions of Kathryn D. Bryan, Archivist, Sears, Roebuck and Company, Chicago; Richard Kszystyniak, USDA Natural Resources Agent, New Haven; Ken Ramage, Editor, Krause Publications, Iola, Wisconsin; and DeWayne Webb, County Extension Agent, Dayton, Tennessee, were equally valuable. Then there is the indispensable Washingtonian Hugh N. Stratford, my *Wizard*, as I like to call him, who is responsible for printing the photographic plates; and Norris Pope, Director, Stanford University Press, my critic and editor.

What a great congregation of independent, friendly advisers these dozens of people are. I admire and thank each and all of them.

Magnificent Failure

Anyone who has traveled out west on our nation's interstates, two-lane highways, or gravel roads has seen countless abandoned buildings. Some are log and some are frame. On the high plains, of the many sod houses that were constructed, only a few survive. In the Southwest and other areas where timber was scarce, buildings were constructed with stone. There are houses, barns, granaries, sheds, chicken coops, and outhouses, whose variety in shape, size, and function is pretty near infinite. But there is a commonality about them. In their own humble way, they are icons. These weathered buildings and rural landscapes are enduring symbols of our agricultural heritage, our rootedness to the land.

Few of us would recognize the direct link from these tattered shacks, log cabins, and modest frame homes to Thomas Jefferson, one of the founding fathers of our nation. But the link is indisputable. Although Jefferson would never see it himself, he had unwavering faith that there was a western garden, an agricultural paradise that offered his young country "a prescription for manageable growth and prosperity on a human scale" (Ronda 1997, xvii). It is the human scale that is so eloquently captured by John Martin Campbell's camera and his informants' experiences.

What Campbell offers his readers is not the niggling little details of the history of public land laws. Instead, he embraces the emotion and texture of individual people and places. Nevertheless, there is something to be said about the irritating twists and turns, the exceptions and exclusions embodied in the vast array of public land laws that attracted settlers to the western hinterlands. Roughly 3,000 public land laws have been enacted by Congress and used in the transfer of 1.2 billion acres of public domain lands to private ownership (Gates 1979, xi, ii).

Each of these laws had nuances that applied to somewhat unique situations and appealed to the circumstances of particular settlers. Similarly, the federal government sought to satisfy

its own objectives. Generating revenue was initially behind land sales but, later, settlement and resource development overshadowed the income motive. As the United States grew to stretch from sea to shining sea, the nation found itself "long on land and short on money" (Gates 1979, 249).

Land became the national currency, and it was a currency that nearly everyone readily accepted. Land was the lure for soldiers who, for serving their country in time of need, were entitled to military bounty lands. There were sales of land on credit and for cash. Land was awarded to territorial and state governments for a variety of reasons, such as admission to the Union, for internal improvements, for schools, and to support the development of agricultural colleges.

The Swamp Land Act provided for the drainage of water from swamp lands, making them suitable for cultivation. Conversely, the Desert Land Act offered up to 640 acres to those ambitious enough to bring water to irrigate arid lands. The Timber Culture Act made it possible for settlers to acquire 160 acres if they would plant 40 acres of trees on their quarter section. And land was the irresistible bait for eastern capitalists, who obtained nearly 100 million acres in exchange for building railroads (Gates 1979). There was hardly a cause that did not benefit from Congress's willingness to offer land as an incentive to states, corporations, and individuals.

Out of the thousands of public land laws the most celebrated cause to receive the attention of Congress and the benefit of public domain lands was that of the homesteader. So pervasive was this cause that the very word "homesteader" took on a meaning that became much more inclusive, much more iconographic than was intended when the Homestead Act was passed in 1862.

Why were the homestead and the homesteader so well endowed with significance? Because from the time of the earliest settlements in the New World, European nations had observed the "head right" of those willing to immigrate to this foreign land. The "head right" was the right or entitlement of individual settlers to 50 acres of land in acknowledgment of their participation in a bold experiment to occupy this uncharted wilderness (Hibbard 1965, 347). In fact, as historian Daniel J. Boorstin (1958, 193) tells us, the perception of an abundance of land resulted in wastefulness. Settlers lacked incentive to husband the land. They were more inclined to "use up" their land, wring every ounce of productivity out of it, and simply move on.

All in all, by the late eighteenth century, land was viewed as an inherent right, a commodity, and a salvation for the young nation. Jefferson fervently believed that the land and the yeoman farmers who worked it would be our country's salvation. He wrote to James Madison that, "Our governments will remain virtuous for many centuries as long as they are chiefly agricultural; and this will be as long as there shall be vacant lands in any part of America" (Boyd 1950, 12:442).

As important as land was, the concept of a person's right to free land was not embraced by all. Free land was at cross purposes with plans to use land to generate revenue for the federal government. One influential backer of free land was Thomas Hart Benton, newspaperman and senator from St. Louis. In an 1826 congressional debate, Senator Benton argued that, "Throughout the New World, from Hudson's Bay to Cape Horn (with the single exception of these United States) land, the gift of God to man, is also the gift of the Government to its citizens" (*Register of Debates* 1826, 2, pt. 1:742).

Benton's position was both benevolent and self-serving. Benton "equated St. Louis with the West, and the West with the nation" (Primm 1998, 113). Given his position in St. Louis, if the West prospered, so would Thomas Hart Benton. But Benton's

view was indeed synonymous with the western view and in opposition to that of the easterners. Easterners were much more market-oriented and saw land as a valuable commodity. The strength of the eastern vote neutralized the western interests for decades. Moreover, the division in the land debate was more than East versus West: it was also rich versus poor, speculator versus settler, and Democrat versus Republican.

From 1825 until the Homestead Act was passed in 1862, the pressure to provide free land for settlers was unyielding. Senator Benton believed that "the settler, in a new country, pays the value of the best land in the privations he endures, in the hardships he encounters, and in the labor he performs" (*Congressional Globe* 1841, 9:132). In 1828 the House Committee on Public Lands also recognized that the purchasing power of the working class of agriculturists suffered a distinct disadvantage. The committee reported,

There are many families who are neither void of industry nor of good moral habits, who have met with the usual share of the difficulties always accompanying the settlement of a new country, and who, living very remote from market, never expect to see the day arrive when they will be enabled to save enough, with all their efforts, from their means of support, to purchase a farm and pay for it in cash. (*Am. St. P.: Pub. Lands* 5:36)

From the 1820s to the 1860s public land policies were formed that established the rationale for expanded settlement and anticipated what would eventually become the Homestead Act. Public land law historian Benjamin Horace Hibbard pointed out that Arkansas legislators attempted to push settlement farther west when they "asked that settlers locating within twenty-four miles of the frontier be given 160 acres of land with the requirement of five years' residence" (1965, 352).

In an "Application . . . for Donations of Land to Actual Set-tlers Upon Condition of Settlement," Indiana representatives urged that donations of land be made to those who resided on the land for five years and made improvements on that land (*Am. St. P.: Pub. Lands* 6:362). In recognition that settlers were likely to "undergo dangers of the frontier," specifically, "Indian attack," donations of land were made to those who ventured to Florida, Oregon, Washington, and New Mexico (Hibbard 1965, 352). Oregon pioneers also benefited from the eagerness of Congress to neutralize any imperial interest England might have in that territory. To further encourage settlement of Oregon, Congress passed "An Act to Create the Office of Surveyor-General of the Public Lands in Oregon, and to Provide for the Survey, and to Make the Donations to the Settlers of the Said Public Lands," under which citizens were allowed to file Donation Land claims, thus increasing the population of U.S. citizens in that Territory (*Stats. at Large of USA* 1851, 9:496). Laws were also passed that hoped to insure bona fide settlement by requiring a minimum period of residence on the land, construction of a house, and cultivation of at least five acres of land (*Stats. at Large of USA* 1850, 5:502–4).

The lessons to be learned from the mosaic of public land laws are clear. Settlers, in addition to helping themselves, became agents of the federal government. They secured remote sections of the country from foreign governments and indigenous peoples. They increased the value of raw land through construction of homes and outbuildings and through the cultivation of the land. And, although they were dispersed throughout the western landscape, they shared a common identity: They were homesteaders!

Long before the Homestead Act of 1862 became law, the concept of what and who homesteads and homesteaders were was widely accepted. The derivation of the word "homestead" is from the Old English *hamstede*. This pre-1150 A.D. word,

composed of the words *ham*, which means "home," and *stede*, which means "place," yields the Anglo-Saxon concept of "the place of one's dwelling or home" (Little 1933, 353). Not that any homesteader ever looked it up or would have cared; they knew what they were doing—they were homesteading.

Jack Campbell's informants were part of that breed. When asked, they would confidently and consistently say they were homesteaders. In Washington, Nevada, Montana, and Kansas, homesteaders did not tend to define themselves on the basis of a particular public land law such as the Homestead Act of 1862. It was not words but deeds that gave them their identity. They were the embodiment of Thomas Jefferson's yeoman farmers. They wrestled with the land, the government, and the banks, believing in their heart and soul that they could win the long, hard-fought battle and claim the coveted prize, land they could call their own.

In spite of the commonsense approach to defining homesteads and homesteaders, historians have often taken a more dogmatic stand. Under their more constricted definition, homesteaders are only those individuals who acquired a parcel of public domain land through the use of one of several specific public land laws which included the word "homestead" in the title of the act.

The first of these was the so-called Homestead Act of 1862 (officially titled "An Act to Secure Homesteads to Actual Settlers on the Public Domain"). This is the act that is commonly called to mind by both avocational and professional historians when the image of the "homestead" is invoked. Passage of the Homestead Act was promoted by westerners who saw a need to stimulate settlement. But it was opposed by eastern states who feared that a flood of free land would depress eastern land values (Gates 1979, 393). Debate regarding a homestead law had

dragged on for decades, creating deadlock and negating all opportunities for passage. The turning point came when the southern states seceded, dramatically shifting the power in Congress to Republicans, who endorsed the homestead concept.

The Homestead Act of 1862 brought together many of the principles that had been tested in earlier public land laws and the concerns that had been raised in congressional debates. To qualify for land using the Homestead Act, an applicant had to be 21 years of age, a citizen (or pursuing citizenship), and the head of a household. The last condition effectively prevented married couples from claiming more than one homestead. Women as a class were not excluded from taking advantage of the Homestead Act, however. A woman could acquire land in her own name as a single person or in lieu of her husband's claim if she was married.

Not only *could* women file for homesteads in their own name, they actually did! One study of women homesteaders found that the number of claimants in selected North Dakota counties ranged from 6 to 20 percent of total homestead applications (Lindgren 1991, 52). In Montana, patents issued to women sometimes went as high as one-third of all patents awarded in selected townships (Brownell and Karsmizki 1990, 17). With today's emphasis on women's history, it is becoming more widely documented that "most families respected and acknowledged women's contributions to the comfort and often the actual survival of the family's life" on the homestead (Myres 1982, 241; see also Muhn 1993 and Rosenfeld 1985). Yet there are still contemporary historians who see women's role as that of the "authentic innocent victim . . . tragic martyrs to their husbands' willful ambitions," rather than as conscious participants in the homesteading process (Limerick 1987, 48).

Under the 1862 Homestead Act, claims were limited to 160

acres or less, "to be located in a body, in conformity with the legal subdivisions of the public lands, and after the same shall have been surveyed" (*Stats. at Large of USA* 1862, 12:392–94). The stipulation that the land had to have been surveyed was a critical one that hearkened back to the Northwest Ordinance of 1785, another piece of work authored by Thomas Jefferson. The ordinance established a Land Office for the United States to handle the disposition of public domain lands, and it proposed that such lands would be surveyed in grids of townships, ranges, and sections, specifying that the survey must precede settlement (Continental Congress 1785, 29:920–21).

As logical and pragmatic as this plan sounded in 1785, there was no way a fluid population of resource-hungry and fiercely independent people wanted to wait for the government surveyors to methodically make their way across the continent. First, surveyors general had to be appointed to the territories and states, then they had to establish initial points from which to begin the survey, contract with independent surveyors, and finally survey the 84 miles of section lines of which each township would be composed—all of which seemed to take forever to impatient would-be settlers.

In Montana, for example, Congress appropriated funds for the survey in 1864, but it was 1867 before a surveyor general was appointed. It was another year before the surveys of the first townships of Montana Territory were approved by the General Land Office in Washington, D.C. Only then could these lands be opened to homesteaders. According to the Homestead Act, applicants could file for their homesteads as early as January 1, 1863, but in Montana the first applicants were on hold until late November of 1868. Other parts of Montana were still awaiting the arrival of the surveyor in the 1920s (Karsmizki 1993). By that time, numerous additional homestead acts had

been passed, and each required a survey to accurately define the boundaries of the claim.

Although no public land law was as popular as the original 1862 Homestead Act, for the sake of the etymologists there might be some value in mentioning other laws that incorporated the word "homestead" in their titles. There was the Soldiers' and Sailors' Homestead Act of 1872, which gave land to honorably discharged military and naval men and allowed them to deduct their time in the service from the minimum five-year residency. Veterans also benefited from the Soldiers' Additional Homestead Provision, which allowed an additional claim, not to exceed a total of 160 acres, if they had previously claimed fewer than the 160 maximum. And Native Americans benefited from the Indian Homestead Act of 1875 (Donaldson 1970, 349).

It is generally thought that the benefits of the Homestead Act fell exclusively to westerners who located beyond the Mississippi, but that is not the case. Applications were filed and patents granted for homesteads in Alabama, Florida, Illinois, Indiana, Michigan, Mississippi, Ohio, and Wisconsin. Southern states in this group were taking advantage of the Southern Homestead Act, which exclusively reserved all public land in five southern states for entry under the Homestead Act (Gates 1979, 444). An interesting aspect of southern homesteads is that the original Homestead Act had been passed largely because southern states had seceded from the Union, shifting the balance of power that allowed the law to be enacted by Congress. Another consequence of the Civil War was that southerners were not permitted to take advantage of the Homestead Act before 1867. After that date they could file for homesteads only if "their loyalty had been unquestioned during the Civil War" (Gates 1979, 444). The Southern Homestead Act was repealed in 1876.

Although there were homestead claims in southern and mid-

western states, by far the greatest number of beneficiaries of the Homestead Act were settlers of the western states. We think of the West as those lands beyond the hundredth meridian, a line that passes through North and South Dakota, Nebraska, Kansas, Oklahoma, and Texas. It was the area beyond this line, according to John Wesley Powell, that constituted the arid regions of the United States (Powell 1878). Not only did Powell's report define the West as an arid region, he argued that agriculture as it was known east of the hundredth meridian only invited tragedy once the line was crossed (White 1991, 227). More to the point, Powell believed that 160-acre homesteads were untenable in the West.

There was no question that the West was an arid landscape, yet Congress was slow to be convinced that these quarter-section homesteads would not work there. Equally vexatious, Congress had passed the Desert Land Act in 1877, allowing claimants up to 640 acres, an amount of land that was more in keeping with Powell's recommendations (Gates 1979, 495). Although larger parcels of land were more in keeping with Powell's recommendations, abuses of the Desert Land Act were excessive, making Congress even more reluctant to consider legislation that might permit claims for larger acreage. By the early twentieth century, pressure was increasing for a solution to the need for larger homesteads in the West. The first attempt at a resolution was the 1904 Kinkaid Homestead Act, which enabled homesteaders to file for 640 acres, but it only applied to land in western Nebraska (Gates 1979, 498).

Another solution to the problems of agriculture in the arid West was the development of dry-farming techniques. According to Mary W. M. Hargreaves, the foremost authority on dry-land agriculture, "Dry farming relates to agriculture without irrigation in regions of semiaridity" (1993, 1; see also Hargreaves

1957). There are two approaches to dry-land farming: one involves the development of drought-resistant plants, and the second relies on methods of cultivation aimed at retaining moisture in the soil. Hardy Webster Campbell, a South Dakota farmer, promoted these cultivation techniques, which he called the "Scientific Farming System." His system required deep plowing, packed subsoil, frequent surface cultivation, and allowing land to lie fallow every other year to retain moisture and reduce evaporation (Campbell 1909).

As might be expected, dry-land farming was endorsed by commercial interests that stood to benefit from the expansion of agriculture into regions that had previously been considered unproductive. Real-estate agents, implement manufacturers, banks, and, most notably, railroads were all strong backers of dry-land farming. The Northern Pacific Railroad not only promoted dry-land farming, it paid for Agricultural Experiment Stations to develop and improve dry-land techniques. If the experiments proved successful, tens of millions of acres that the railroad had acquired through land grants would become more marketable, yielding higher sales prices (Cotroneo 1987).

The land grant was the railroad's greatest asset in more ways than one. Sale of this land generated revenues to offset the costs of railroad construction. Equally important, the railroads' primary income was dependent upon shipping freight and hauling passengers. With a stable population of settlers, the railroads would be guaranteed a steady inflow of freight—agricultural implements, equipment, seed, supplies, and household goods—to these new rural communities, as well as an outflow of farm and ranch products that needed to be brought to market. For these reasons, railroads did everything they could to stimulate settlement. They opened emigration offices in foreign countries, they gave prospective settlers reduced rates for themselves and

their possessions, and they developed strategies for building townsites that would serve the needs of rural communities while also creating centralized shipping and receiving points (Hamburg 1975; Iseminger 1981; Karsmizki 1994).

As the railroads worked to accommodate the settlers by building a transportation grid that connected western communities with urban markets, Congress continued to adapt public land laws to the needs of the arid West. One solution was passage of the Forest Homestead Act of 1906, which allowed for settlement of the large forest reserves that had previously been set aside and off-limits to settlers (Hibbard 1965, 394). Shortly thereafter, the Enlarged Homestead Act of 1909 was passed, which allowed claims of up to 320 acres, twice the acreage allowed under the Homestead Act of 1862 (Gates 1979, 504).

Next came the Three-Year Homestead Act of 1912, which shortened the period of residency required before an applicant could "prove up" his or her claim from five years to three years (Robbins 1942). Shorter periods of residency certainly reduced the anxiety and risks of prospective settlers. Now able to receive title to the land more quickly, they could then convert their stake into cash, either through mortgage or sale. Finally, in 1916, in an attempt to address the need for larger acreage for grazing livestock, Congress passed the Stock Raising Homestead Act (Muhn and Stuart 1988, 36). Stock-raising homesteads were typically 640 acres, but experience would prove that this type of concentrated grazing resulted in extensive damage to rangelands.

Efforts to legislate the reclamation of North America's arid lands and make them agriculturally productive through homesteading did not cease with the marginal success or abject failure of one public land law after another. The drive to irrigation was the force behind the Desert Land Act of 1877, and was also the basis of the Newlands Reclamation Act of 1902. The former law made settlers responsible for developing irrigation; the latter shifted this responsibility to the federal government.

The firm belief that all the arid West needed to make it bloom was water led to new schemes, such as the All-American Canal and the Central Valley Project in California, the Minidoka Project in Idaho, and the Grand Coulee in Washington. These projects, and others like them, expanded the western agricultural base, particularly after World War II. Even at that late date, in the second half of the twentieth century, the federal government could boast that "The lure of homesteads in the West is still strong" (House 1959, 21–23).

All of these public land laws endeavored to mitigate the harsh realities of life in the North American desert. They were social experiments, ecological experiments, and legislative experiments. They mixed abundant land and scarce water with people who had ideals and dreams. The formula included technological innovations and, in the cases of railroads and public irrigation programs, massive quantities of cash.

But on the human scale it was typically hard work, sweat, and often tears that made homesteading what it was. To get titles to their farms (Plate 2) settlers were required to live on their land for a minimum of three years (after 1912) and they had only seven years total before they had to "prove up" on their claim. Proving up meant that they had to demonstrate that they had met the conditions of the Homestead Act, which were that they lived on their claim, had built a home there, and had cultivated at least a portion of the land.

Homestead applicants were required to submit a written final proof, swearing that they met all these conditions and that the only beneficiaries of their labor were their own immediate family. Two neighbors also had to testify that the applicant had indeed resided on the land and had cultivated it, as well as de-

scribe the improvements made—the size of the house, barn, and outbuildings. For those scholars who enjoy archival work, the National Archives holds case files for each and every homestead that went to patent, and these public documents contain a wealth of information.

But for the anthropologist, there is another route to understanding the depth and variety of the homestead experience. That route lies along the roads less traveled. Jack Campbell has examined the architectural remnants of times past. He has taken the time to converse with those who know homesteading, not by reading books but by nursing blisters earned the hard way, by building, plowing, milking, and herding. These informants will not live forever. Eventually, even the artifacts they leave behind, the machinery, a rusted-out car, the humble buildings, and the rural agricultural landscapes, will disappear. Thanks to John Martin Campbell, his anthropological training, and his trusty camera, not all will be forever lost.

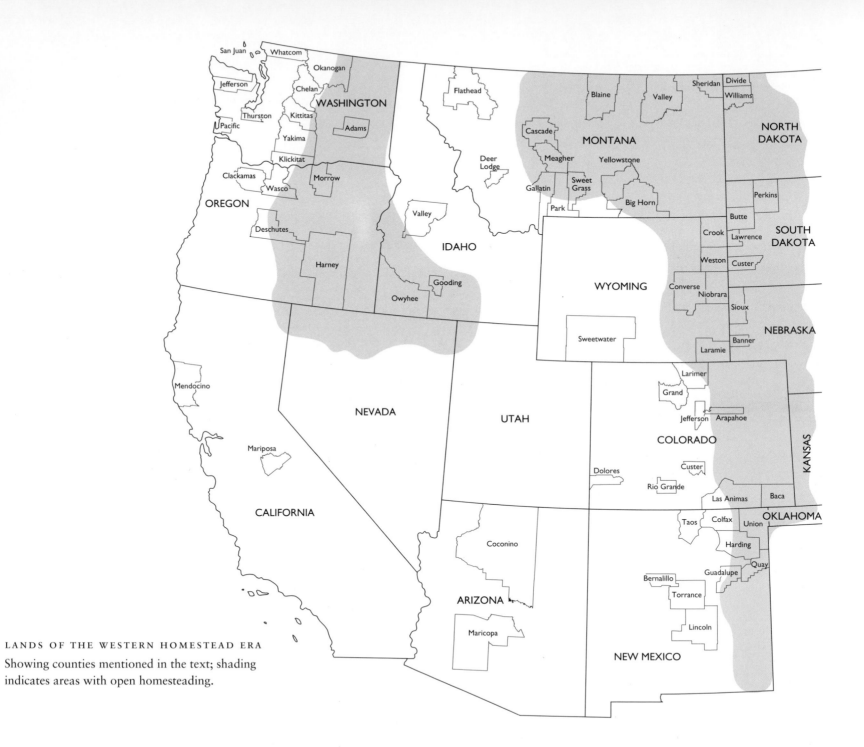

San Juan
Whatcom
Jefferson
Okanogan
Chelan
Thurston
Kittitas
WASHINGTON
Pacific
Adams
Yakima
Klickitat
Clackamas
Morrow
Wasco
Deschutes
OREGON
Harney
Flathead
Deer
Lodge
Cascade
Meagher
MONTANA
Yellowstone
Gallatin
Sweet
Grass
Park
Big Horn
Valley
IDAHO
Gooding
Owyhee
Blaine
Valley
Sheridan
Divide
Williams
NORTH
DAKOTA
Perkins
Butte
SOUTH
DAKOTA
Crook
Lawrence
Weston
Custer
WYOMING
Converse
Niobrara
Sioux
NEBRASKA
Banner
Sweetwater
Laramie
Larimer
Grand
Jefferson
Arapahoe
COLORADO
Mendocino
Mariposa
NEVADA
UTAH
Dolores
Custer
Rio Grande
Las Animas
Baca
KANSAS
OKLAHOMA
Taos
Colfax
Union
CALIFORNIA
Coconino
Harding
Quay
ARIZONA
Guadalupe
Bernalillo
Torrance
Maricopa
Lincoln
NEW MEXICO

LANDS OF THE WESTERN HOMESTEAD ERA
Showing counties mentioned in the text; shading indicates areas with open homesteading.

When I was seven or eight I was shown the ruins of a farming community on the rolling sagebrush prairie of Yakima County, Washington (see map, opposite). If it had not been for my father's love of gun dogs, I probably never would have seen the place, nor would I have heard its story. What little there was left of it was hidden away in the sagebrush, miles from the nearest all-weather road, and my father and I arrived among its abandoned fields to hunt sage hens, not to visit ghost towns. Actually, I do not remember our finding birds that particular afternoon, but I do remember my fascination with the ruins, and with my father's summary account of the rise and fall of the deserted community (the details of which were refreshed and augmented in later decades).

My father explained that years earlier, farmers had settled here, but that after building their houses, and clearing and planting their fields, they had discovered that without irrigation the climate was too dry for farming. Then the settlers realized that a small neighboring creek could provide the essential water if it could be dammed to create a reservoir. So they built a tall concrete dam. But before it could do any good, it was washed out by a desert cloudburst. The farmers, having used up all their money, packed up and moved away.

In its telling, the story took appreciably longer than it has here, because as he talked my father was both showing me the forlorn evidence of the town and keeping track of our two English setters. Fifty years after that day, Robert Lince published his account of the story as part of a broader study (1984, 60–61). By then, of course, I had forgotten much of what I had heard and seen on that fall day in 1934 or 1935. But I did remember the gist of the story, and I remembered the tumbledown houses, and, most clearly, the remnants of the concrete dam whose shattered abutments still clung to the steep banks of Selah Creek.

In the early 1990s, while I was working on *The Prairie Schoolhouse*, I came to realize that,

in its microcosmic way, the abandoned settlement on Selah Creek represented quite accurately the entire history of the western homestead era. Its ruins lay on an open prairie, the farmers had failed because of the nature of the dry-land West, and each of the families had lost a farm that it actually owned, or was in the process of owning, rather than land belonging to someone else.

In theory, nearly all the West had been open to homesteading (the exceptions being previously established towns and cities, military and Indian reservations, and various private holdings, including land grants). But in practice, more than 90 percent of the country lying between the longitude of westernmost North Dakota and the Pacific Ocean defied homesteading. That was because the 1862 Homestead Act applied only to farming, and this region was composed of immense, waterless western deserts, imposing mountains (including the Rockies and Cascades), and even rain forests (in the Pacific Northwest). Additionally, much of the good farming land in the region, land with readily accessible irrigation water, had already been claimed, either by corporate entities or by the relatively few homesteaders who had arrived before 1885.

In all of the West, this dry country—both the desert and the somewhat less-arid lands—was impossible to farm without irrigation, an argument made by Major John Wesley Powell, who headed up the U.S. Geographical and Geological Survey (see Kenneth Karsmizki's Introduction to this volume). Before Congress, Powell noted that because of the desert nature of the landscape, enormous sections of several western states (including all of Nevada) were totally unsuitable to farming, and especially given the limited acreage allowed to each farmer under the Homestead Act. At the time, Powell's stance was strongly rebutted by several western U.S. senators, who feared the effects of negative publicity for the settlement of the West, but we shall see how right he was.

The most promising of the western landscapes were the prairies. Because of their gentle topography and thin, easily plowed cover of grasses or sage, they seemed to offer good, if not ideal, farming conditions (Plates 1, 3). Topographically, much of this open land was identical to that of the Corn Belt, the tallgrass region of the Midwest, with the singular difference being that the tallgrass country received considerably more rain and snow than its western counterparts). It was to this far off prairie country that a large majority of western era homesteaders were attracted. Including spouses, other adult family members, and children, a total of about seven million people homesteaded on about three million claims. Of those homesteaders of record, 25 percent were women and between one-fourth and one-third were recently arrived immigrants from Great Britain and mainland Europe (Campbell 1996, 9). The opening of these lands had generated something akin to a gold rush, although in a less frenetic and more genteel sense. Among the new settlers were people of all ages and from every walk of life. The western homestead era had arrived.

Beginning then in about 1885, these would-be western farmers flocked to the shortgrass prairie country and beyond to the Rockies and the Pacific Northwest. They were prompted by a wide array of hopes and motives, but among the most abiding was the belief that homesteading in the West promised adventure as well as economic betterment. It took a dull mind not to find a certain romance in this still half-wild country, and indeed, for quite a few of the pilgrims, it was the glamour of the enterprise rather than prospective financial success that lured them on. Excepting those who quit early without really trying (see Chapter 4), most who stayed the course seem to have belonged to one of two heterogeneous classes: they were "romantics," who homesteaded for aesthetic, social, or political reasons; or

they were among those whose dream it was to make of homesteading a lucrative business.[1]

As I have described, discouraging conditions such as high altitude or waterless deserts made homesteading in most of the West a difficult proposition at best. Nevertheless, some "romantics" insisted on giving homesteading a try. Most failed, but others, improbably, managed to make a go of it in impressively marginal environments. The many thousands who tried made up two distinct populations. The largest number were composed of what one might call "subsistence homesteaders," and a smaller number fell into a group that might be called "recreational homesteaders."

As used here, the term *subsistence homesteaders* means those settlers whose farms provided only marginal necessities and comforts of life. To achieve a higher, if still moderate, standard of living, these settlers harvested wild resources and often sought out part-time wage work, if it was available. The chance to make any real money, to make of homesteading a flourishing business, was hardly an option. Coastal shorelines, desert canyons, and mountain meadows were their common choices among available parcels. Typically, these homesteads were located in remote areas and round-trips to the nearest town or trading post often involved several days of arduous travel. But this was all part of the plan, for while it would be unfair to characterize subsistence homesteaders as antisocial cranks (although some of them were), they all generally shared a love of solitude and an ideal of living *way out there*.

Most were lean of pocket; their grubstakes were small. So variously they eked out a living by hunting, fishing, trapping, collecting wild plants, and trading. But they were honest homesteaders, plowing, planting, and making legally required improvements even as their enterprises suffered from poor soils, little water, or short growing seasons.[2] Still, their bank loans, if any, were minimal, and farm-market fluctuations hardly touched them because they had so little to sell. Thus, for those of this frame of mind, who hung on and proved up, subsistence homesteading had its own special rewards.

The story of the Fontaines is a classic case in point (Gossett 1979, 245–47).[3] John and Maud Fontaine, having arrived from the East in 1910, filed on 80 acres beside the Naches River, 50 miles (most of them by wagon road) above the town of Yakima, Washington. It was an appealing site, with pine-clad ridges towering over their camp on the river bank, but the "Fontaine Place," as it came to be called, was nevertheless a poor excuse for a money-making farm. At 2,000 feet above sea level, and at a latitude of 47 degrees north, the homestead had a growing season of just ninety days per year.

About one-third of the total acreage was composed of precipitous slope. The remainder, a rocky flat beside the river, contained both dry meadows and an open forest of ancient ponderosa pines and Douglas firs. By cutting most of the trees, building a check dam in the Naches, and digging irrigation ditches, the Fontaines, who had no children, managed to bring the farm up to the required agricultural specifications. Part of their irrigated acreage became wet pasture; the rest was plowed and put into alfalfa (the cloverlike legume that for years has been the most popular western hay).

Starting with a team of horses and working together at clearing and plowing and the other labor involved in proving up, in five years the Fontaines had built a good, small house and a smallish barn, were cultivating a kitchen garden of limited variety, and were keeping chickens, a milk cow, and a few head of beef cattle (Plate 4). They sold the steers downriver at the railhead town of Naches, 15 miles above Yakima. Mr. Fontaine

trapped "mink and orters," as he used to tell my brother and me, and he also took the occasional brief job with the U.S. Forest Service. Mrs. Fontaine sold milk, eggs, and meals to passersby, whose numbers were few and far between.

Altogether, their income amounted to a few hundred dollars per year, but there were deer in the hills, trout and salmon in the river, and in a good season a whole mountainside of huckleberries within a day's horseback ride. Were they happy? Yes. Frugal and industrious, they achieved a level of success which eventually allotted them a pickup truck, a few nice things from Sears and Roebuck, and such desirables as Dundee marmalade and anchovy paste from Donald MacIver's mercantile establishment in Naches. The Fontaines reflected perfectly the romantic ideal of wilderness self-sufficiency.

One would suppose, because children were so important in so many ways on the homestead frontier (Campbell 1996), that the Fontaines regretted being childless. But on all accounts, theirs was a devoted partnership, and according to my elders, if anything, Maud Fontaine got more fun out of homesteading than did her husband John. Maud handled all the finances for the homestead: she kept the books; set the prices for milk, cream, fryers and eggs; and again according to my elders, was the engine who drove the farm. In the 1920s and still working hard, the Fontaines sold some of their riverfront to summer people, Scots and Swedes who lived far downstream in the direction of Yakima (and who included my mother's family, the above-mentioned Donald MacIvers). Later still, after both of them were dead, the remainder of the homestead was sold. The old homestead thus became one of thousands of its kind, now distinguished by elegant year-round houses worth more money individually than the Fontaines ever dreamed of.

The second subset of the "romantic" homesteaders, whose numbers were considerably smaller than those of the subsistence farmers, was the *recreational homesteaders*. Quite unlike the Fontaines and those of their ilk, these idealists were more or less well heeled when they sought to embark on their homesteading adventure. Their goal was to "get away from it all," and their homesteading had nothing to do with having to make a living. The somewhat cockeyed eastern lady whose prairie mansion is shown in Plate 39 was one of them. Most often, these "farms" were located in desert, seashore, or high mountain settings, which offered their proprietors nothing in the way of honest farming, and whose proving up, to put it politely, required considerable ingenuity. Most of these recreational homesteaders dropped by the wayside, but quite a few of them succeeded, and this writer has seen their so-called "farms," some of which now survive as fancy getaways, scattered over the landscape from Alaska to New Mexico.

A Scottish American, whom I shall call Sandy, provides a fascinating example of this type of homesteader. During the Korean conflict, before going off to the war, I was stationed briefly at Mountain Home Air Force Base—which despite its name is sited on the desert prairies of Elmore County in southern Idaho. That's where I met Sandy in 1952. Sandy's trailer house, less than an hour's drive from the base, stood in the sagebrush a mile or so back from the left bank of the Snake River amidst a 600-acre field of tall sand dunes. Then in his late thirties, he told me that he had filed on 80 acres, nearly all of them covered with dunes, two years earlier. He explained that he was a civilian accountant who worked full-time on the base, and that he was improving his homestead after work and on weekends. He had dug a well and a cesspool and was in the process of figuring out how to pipe in electricity, meanwhile getting along with a gasoline-powered generator. Thus, he had met the federal stipu-

lation of a habitable house, but not unnaturally was having problems with the agricultural requirement. The tall dunes were not amenable to cultivation, nor, it seemed, were the few flat acres lying among them, since the only water to be had in that small corner of the sagebrush desert was what could be pumped from Sandy's domestic well.

From my most recent inquiries, it appears that the subsequent history of Sandy's venture has been lost in the sands of bureaucratic paperwork. But local lore has it that he obtained his deed in 1954 or 1955, proving up, as it happened, in the biggest and most spectacular dune field in the state of Idaho. The state later bought him out, and, after acquiring additional lands from the federal government, went on to establish Bruneau Dunes State Park. Cynics might argue that Sandy knew all along that he was sitting on a valuable piece of property, but that is not true. In 1950, when he filed, and for years afterward, the popularity of the Idaho dunes was zero. No, he filed there, Sandy told me happily, for the simple reason that he had always liked sand dunes. He was a delightful nut, Sandy was. In the summer of 1999, after a forty-eight-year absence, this former Air Force lieutenant drove down to see Sandy's homestead. Everything was still there, except for the man and his trailer house. And I missed them.

But by far the most prominent and numerous of the western homesteaders were neither subsistence nor recreational homesteaders. They were business farmers who aimed to make money from homesteading, enough at least to provide for a comfortable living. Probably, they accounted for 90 percent of the adults who participated in homesteading during the western era. Among their ranks, alas, could be found an unknown number of illegal operators, land promoters and speculators who hired stand-ins to fulfill the Homestead Act's residency requirement. And it has been said that wealthy sheep- and cattlemen sometimes per-

suaded their numerous employees to file for homesteads, with the idea that their patents, when finally obtained, would be signed over to these ranchers.

Most of the newcomers, however, were honest. They were more practical than the "romantics" and so avoided the out-of-the-way places that so attracted those idealists, although as the best lands were taken, numerous latecomers did file in marginal localities. Growing crops on a lucrative commercial scale demands easy access to markets, so a lonesome farm that lay many miles up a dirt wagon road, such as that of the Fontaines, was to be avoided. Important, too, were climate and topographical conditions. For all these reasons, homesteaders who aspired to make money settled on the open western lands of the prairies or the plains.

The more eastern of the two is the shortgrass prairie country, of the kind mentioned in the Preface, and in the United States it reached from southern New Mexico to the Canadian border, and from the longitude of the western Dakotas to the eastern foot of the Rockies. The other, the more western, encompasses the sagebrush plains of the intermontane Northwest, including, primarily, parts of Washington, Oregon, Idaho, and Nevada. With some exceptions, both regions had growing seasons adequate for two or more major cash crops, and both had excellent if somewhat different soils. But neither of them, practically speaking, offered the prospect of artificial irrigation. Good open lands whose proximity to creeks and rivers allowed for irrigated farms had been claimed long before most of the homesteaders arrived (see Plate 10). The late-coming prairie settlers, most of whom reached the western prairies shortly after 1900, were of necessity left to dry farm, depending on directly falling rain and snow for the water required.[4] In this group were Moody and Suzie Lucille Cherry and their children, a Tennessee family, by way of Texas, who ar-

rived in Union County, New Mexico, in 1912. Much of the prairie in Union County had been settled earlier by homesteaders who had arrived with the railroad. The Cherrys also arrived by train, Moody riding in a boxcar with the family's household goods, farm implements, and some livestock, while Suzie Lucille and the three children rode coach. Upon arriving in the village of Grenville, Moody "bought out" another would-be homesteader who was ready to quit. For months, the Cherrys lived in an abandoned boxcar alongside the tracks of the Colorado and Southern Railroad. Having completed the residency and other requirements on their piece of ground, the Cherrys finally became legal owners of their first 160 acres of Union County farmland. The family would later file on adjacent land, until by 1920 they had acquired a square mile.[5]

In most all respects, Union County met the American farming ideal. Life on the lonesome buffalo prairies was not for everyone, but for those who stuck with it, prosperity seemed assured. These high prairies lie more than 5,000 feet above sea level, but at the relatively southern latitude of 36 degrees north. The growing season is some 150 days per year, and the soils, while shallow, are rich. The Cherry homesteads, and those of their neighbors, received between 18 and 20 inches of annual precipitation, enough to grow an array of cash crops. In the early years of the twentieth century, the county filled with farmers. More than a dozen homestead towns (including Sofia, settled by immigrant Bulgar farmers) were connected up by ancillary rails to the Colorado and Southern. In this milieu, the Cherrys prospered, and we shall look at their life and times further in Chapters 3 and 4.

For both subsistence homesteaders and those who aspired to commercial farming, there was typically an initial overlap in standard of living. Even the Cherrys, who arrived as a family with farm machines and household goods, began western prairie life in an abandoned railroad boxcar. Indeed, many, if not most, homesteaders struggled to get started, enduring a level of poverty which by today's standards would be considered unacceptable. A grubstake of $300 was considered a lot of money; more often, one's total cash resources were about half that, and much of it was spent on the implements necessary to building, plowing, and planting. Settling in required, first, a set of hand tools, including most essentially a claw hammer, assorted nails, a crosscut saw (Plate 5), a pocket or belt knife, an axe, a splitting mall and wedge, a long-handled shovel, a pick, and a grub hoe.[1] With these tools a reasonably handy homesteader could cobble together one or another sort of homemade dwelling, a bed or sleeping bench, and assorted furniture (although most homesteaders arrived with at least a few furnishings).

For housekeeping, the typical list of first utensils included a 15-gallon galvanized washtub, a washboard, a 3-gallon water bucket, plates, cups, frying pan, sauce pan, coffee pot, table knives and forks, a butcher knife, and the ubiquitous and well-nigh-indispensable kerosene lantern (Plate 6). Not uncommonly, cooking was done initially at an outside, open hearth, but an interior stove, capable of burning wood, coal, cow chips, or whatever, soon became a universal homestead fixture. The law required that one-eighth of the homestead be in cultivation within the first three years of occupancy, so the single most essential implement for getting started was a walking plow (Plate 7). A horse, or far better, two horses, together with harness, "tree," and reins were also essentials. Other necessities included clothing and bedding, seed, soap, matches, and the like. In the first decade of the twentieth century, all of them together,

including stove and plow, cost less than $200 (see Schroeder 1971), and a good saddle-cum-workhorse sold for about $20.

Often miles from the nearest town, the typical homestead and its environs provided most of the new homesteader's diet. Salt, sugar, flour, dried beans, coffee, canned milk, and a few cans of fruit were bought in town, but most fresh vegetables came only from the homesteader's own kitchen garden, whose size depended upon personal ambition, time available, and water supply, and whose productivity reflected such variables as length of growing season and ethnic preference. On the high, cold prairies of northern Montana (Plate 10) one cannot grow corn, squash, beans, potatoes, melons, or tomatoes, and altitude combined with latitude affected equally the sorts of "green truck" and "roots" the would-be farmers could get from their kitchen plots. In the region of Albuquerque, New Mexico, for example, an impressive array of domestic food plants—including the celebrated corn, beans, and squash of the ancient Pueblo Indians—will thrive at more than 5,000 feet above sea level, but even at 4,000 feet, in Yakima County, Washington, one cannot grow a single vegetable.

Two principal varieties of radish were the most universally popular of the farmers' home-grown fare, if for no other reason than that they were so easily cultivated and so tolerant of marginal soils. More important than radishes, but requiring more attention, potatoes were another popular home-garden vegetable, as were green onions, cucumbers ("cukes"), Hubbard squash, and, climate permitting, a row or two of sweet corn. Lettuce, peas, tomatoes, and string beans were sometimes included, but because of climate, cutworms, blight, or the forays of field mice and wild rabbits, these were harder to grow. There were also the long-standing national or regional favorites, brought west from Europe, New England, or the Old South. Among others, these included cabbage, okra, sweet potato, rhubarb, and rutabaga. Seeds or cuttings were cheap and easy to transport. A packet of radish seeds cost 5 cents, would fit in a shirt pocket, and with a little luck would produce all the radishes one could eat. (Nowadays, the same packet sells for $1.98, but in size and design it is nearly identical to its turn-of-the-century counterpart.)

In addition to vegetables, and especially in the absence of vitamin pills and other modern food supplements, animal protein was a critical necessity. Homesteaders sometimes traveled west with laying hens and fryers, and it was hoped that future success would allow for the acquisition of hogs, steers, and lambs. In the meantime, game birds, rabbits, deer, and other wild game more or less met the dietary requirements of settlers. On the prairies, rabbits (both cottontails and the big hares called jackrabbits) were the most universal game because they were often abundant and available in all seasons. I recall my father reciting this couplet, acquired during his own western homesteading days: "Since bacon's gone up to a dollar a pound, I eat so much jackrabbit I go hopping around." On the prairies, fish often came only in cans, but in other locales, most notably in the northwestern country, whose streams reach salt water a few miles or a few hundred miles from their sources, fish were abundant and were caught with a variety of nets and rods, often homemade.

Fish or no fish, a homestead without a firearm was a rarity. Nearly as rare, however, was its use as a weapon. Among westerners, Indian warriors and cowboys notwithstanding, homesteaders were second only to missionaries in peaceful intent. They had very little to offer desperadoes in the way of booty, and hard put as they were at trying to succeed at farming, most had neither the time nor the inclination to get into trouble.[2] Firearms, therefore, were domestic tools in the same sense as the axe or plow. The universal firearm was a rifle, sometimes accompanied by a

shotgun, and their main purpose was to kill animals for food. Otherwise, they might be used as defensive weapons to kill such marauders as chicken-stealing coyotes.[3] Thus, with a kitchen garden and foraging, the neophyte western homesteader kept body and soul together.

Shelter for both man and beast began with tents and rude stone or log structures (Plate 11). Based on the testimony of my informants, I estimate that 70 percent or more of the first homestead dwellings were canvas tents, lean-tos, or hovels made of packing boxes and other flimsy materials. The tents, given refinements by the American Civil War, were by the advent of the western era both durable and inexpensive. When furnished with a tin stove, a rectangular canvas wall tent measuring 8 by 10 feet would more or less comfortably accommodate two adults. Including the stove and a stovepipe, these tents sold for about $12 as late as 1908 (Schroeder 1971, 763–65).

In the northern latitudes, however, a canvas tent (not to be confused with the marvelous buffalo-hide lodges of the Plains Indians) was a miserable winter dwelling, and even on the southern prairies of Colorado and New Mexico, it was hardly an all-season house. Consequently, within a few weeks or months, most homesteaders sought to replace their tents with more substantial housing, generally constructed with milled lumber, logs, native stone, or adobe. A few houses were constructed of sod, and some were nothing more than dugouts, houses dug horizontally in cut banks or vertically on open ground (Plates 12, 13; see also Campbell 1996, plates 8, 9). These first houses were small, sometimes no larger than a tent (especially when they were built by a bachelor), but they were built to last, and today one can still see the ruins of these solitary relics. Many are all that are left of homesteads that were abandoned before their prospective owners obtained title; others were kept as "souvenirs" and sit along-side the more permanent houses that were later constructed on proved-up farms.[4]

These initial dwellings and the larger houses that followed show distinctive geographical variations that reflect the raw materials of construction that were available. Houses made of adobe were abundant on the prairies of New Mexico and southern Colorado (Plates 14, 15). The technique for making the adobe bricks, sun-dried mud tempered with straw, was handed down from descendants of Spanish-Mexican settlers. On the Colorado and New Mexico prairies, a land of few trees but with abundant shallow sandstone and limestone bedrock, thousands of homestead houses were built of trimmed stone blocks (Plate 16). And farther north, on the arable flanks of the Black Hills, the Rockies, and the Cascades, where trees were more abundant, log cabins were the standard type of construction (Plate 17).

Surprisingly, given that so many homesteaders arrived in the West with little in the way of cash resources, first dwellings were often replaced with houses constructed of milled lumber instead of native materials (Plate 18). This was particularly true on the northern prairies of North Dakota and eastern Montana. The lumber, purchased at railroad towns like Rapid City, South Dakota, and Glasgow, Montana, and hauled out to the farms in horse-drawn wagons, required considerable outlays of cash. Considering their cost, such houses were cold; their wood and plaster walls, including four inches of hollow center, were only seven inches thick (see Campbell 1996, plate 16). Still, in the absence of logs, adobe, or building stones, over much of the wind-swept northern plains wood houses were the only alternative to temporary makeshifts. That they were built by homesteaders who had little money to spare testifies to the frugality and determination of the German, Norwegian, Scottish, and Ukrainian immigrants who settled on the northern prairies.

With effort and the right kind of soil for digging, a dugout could be surprisingly snug and attractive, but as a permanent dwelling it was not widely popular. I suspect that dugouts were considered more as eccentric curiosities than "normal" houses. Once homesteaders graduated from their initial tents, more than 90 percent built permanent dwellings of the simple, gabled type that since colonial times had been the typical, vernacular North American house (Plate 16). Distinguished by its elongate rectangular plan—its width usually being two-thirds its length—these houses have a single, central gable or ridge that runs all or some of the length of the long axis of its pitched roof.

Native Indian tribes of the Northwest coast built similar dwellings long before the arrival of Europeans, but the homesteaders' gabled houses were based on ancient Eurasian designs.[5] Introduced by early colonists to New England and elsewhere along the Atlantic seaboard, this simple house type soon was duplicated all over North America, in dwellings (including Abe Lincoln's log cabin), schoolhouses, barns, and other related structures. A large number of these early western homestead houses have long since been destroyed (often deliberately, for their lumber or stone blocks), but many survive, usually as abandoned derelicts. In our field studies we counted a total of 757 examples. Most were of milled lumber, but about 5 percent were of logs (usually left untrimmed except for their interlocking ends). Houses constructed of native stone or adobe, respectively, accounted for less than 5 percent of our total, and these were restricted to the southern prairies. The special geography of that landscape, together with the instability of stone walls laid up with mud mortar and the fragility of adobe bricks, explains the small percentages.

Whatever construction materials may have been used, in its more simple form the gabled house contains one or two rooms, one door, two windows, and often an attic. Our measurements of fifty-four houses averaged 15 by 21 feet in external plan, and 13 feet from ground to ridge. We were able to distinguish two variations in the rooflines of these dwellings, a *gabled-plain* style and a *hipped* style. The former denotes a central ridge, or gable, that runs the length of the roof's long axis (Plates 16, 17, 18), whereas the latter denotes a roof foreshortened an equal distance from each end of the gable (Plates 14, 19). Our sample contains 592 gabled-plain roofs and 165 hipped roofs. (The latter, for reasons obscure, are far more common in New Mexico; there, the number of hipped roofs equals the number of gabled-plain roofs.) I was unable to discern any social or environmental factors that might explain the choice of one design over another; the two styles seem to reflect aesthetic preferences rather than functional differences. In my travels, I noted other small, early homestead houses with different roofline designs: *pyramidal*, *saltbox*, *Dutch colonial*, and *mansard*. Altogether, the number of houses using these styles totaled fifty-nine, of which thirty-five displayed a pyramidal roof style. Regardless of roofline, when the western homesteaders built their first "good" house, the vernacular North American house was their choice more than nine times out of ten. Moreover, the earliest western churches were often of identical design (Plate 20).

Shelter for livestock, particularly horses, could be as critical as shelter for the farmer himself. Along with a family's much loved dog or dogs, horses were often the only domestic animals that arrived along with the homesteaders. Commonly, these were saddle horses that doubled as plow horses, and without them, there would have been no western homesteading in the first place. The plow horse, as its name implies, pulled the walking plow (Plate 7), the farming implement of most singular importance to proving up on western homesteads.

A first requirement in keeping horses, cattle, and sheep was the availability of large quantities of fodder, provided by wild green pasturage in summer, and, initially, in winter by the same wild grasses cut, cured, and put up as hay. When a farmer's pocketbook permitted, hay for the horses would be supplemented from time to time with store-bought oats. Ordinarily, in summer little in the way of shelter was necessary for the horses (and sheep or cattle, if the homesteader had any), but even on the salubrious southern prairies, winter could be a different matter entirely. (As recently as the winter of 1997–98, 35,000 cattle and 60,000 sheep perished in a catastrophic snowstorm on the old homestead lands of eastern New Mexico [Linthicum and Pipes 1996]).

As western farming and stock growing developed, some homesteaders gambled that the winter would be mild enough that their flocks or herds could survive in the open. Others built big barns specifically designed to house large numbers of wintering livestock. Still others shipped their animals to feedlots or slaughterhouses each fall, thus avoiding the hazards of bad winters. Horses, in fact, are more likely to survive severe winter weather than sheep or cattle, but no new farmer would risk losing his horses, and accordingly the neophytes contrived an imaginative array of horse shelters. Ranging from dugout stalls, to log cribs roofed with poles and dirt, to similarly roofed bedrock crannies, to occasional small log or milled-lumber sheds (Plate 11), these were the first western homestead barns.

As happened with the western homestead dwelling, the construction of a more permanent barn heralded the homesteader's continuing success. In exterior design, the barns were nearly identical to the gabled-plain houses described above, each exhibiting a central ridge that ran the length of the pitched roof. Small, as barns go, but larger than the houses, our measurements of sixteen examples produced an average external plan of 22 by 34 feet, and an average height from ground to ridge of 20 feet. Their ground levels contained little else than pens or stalls for livestock—horses principally—and an upper loft held hay (Plates 22, 23).

The small but well-built early barns and houses that survive are sure reflections that some homesteaders were getting ahead— they were making a go of it, and with luck and hard work, success lay just around the corner.

Becoming prosperous at western dry farming had much to do with the luck of the draw. To most of the newcomers, one stretch of shortgrass or sagebrush looked pretty much like any other. But there were telling climatic differences across the prairies, and as we shall see, these differences were to become more pronounced with the passage of time. Making dry farming a paying business required good ground, enough water, a sufficiently long growing season, and efficient transportation networks to get the crop to market. With rare exceptions, shortgrass and big sage soils were plenty fertile enough, and with the promise of profit, numerous companies, both large and small, were soon laying rails into the productive prairie farmlands (Plates 25, 26). But making money hinged most critically on ample precipitation and on a sufficiently long growing season, and with a few exceptions, only two big, discontinuous regions offered this essential combination. The first lay in a broad strip of shortgrass that reached southward from the North Dakota–Montana border to eastern New Mexico; the second was located in the intermontane sagebrush country, extending northward from northeastern Oregon into much of eastern Washington. These two widely separated regions were the moneymakers. Both were settled early, in the 1890s or shortly afterward, but it was luck rather than knowledge that landed most dry-farming pioneers in these two salubrious climes. And the Cherry family of Union County, New Mexico, was among the lucky.

Actually, Moody Cherry and his family were not in the vanguard of settlement in eastern New Mexico. Back in Texas they had heard that there was good homesteading to be had just across the New Mexico border, and, in fact, Moody had scouted ahead before bringing his family out in 1912. In addition to a great deal of hard work, making real money at western dry farming required sophisticated farm machines capable of plowing, planting, and harvesting hundreds of acres or more. These implements were pulled by either horses or gasoline-

powered tractors, which required as their drivers and attendants no more than one or a few adults. Farmers and farm implement dealers being what they were—and are still—varieties of these machines ran into hundreds of models, but at base only four such artifacts were absolutely necessary to the success of the Cherrys and others like them.

The first was a large plow to turn under either virgin prairie or harvested farmland. These came in several designs. The example shown in Plate 27 has a total of eleven big blades and, accordingly, would plow a quarter section or more in a fraction of the time required by its "walking" predecessor (Plate 7). The second essential machine was the harrow (Plate 28), a multi-toothed implement that broke the clods produced by plowing into exceedingly small clods, thus preparing the ground for planting. Next was the drill (Plate 29), a sophisticated machine which, as it was pulled across the fields, plowed furrows in the prepared ground, planted them with seed, and covered them over with soil. And finally there was a wide range of harvesters (Plates 30, 31), machines that dug, mowed, cut, bundled, and threshed according to the particular crop at hand. These were the essentials for farming commercially. With machines like these, the Cherrys produced milo maize, sorghum, pinto beans, broom straw, and for a year or two, even potatoes.

The market for pinto (navy) beans collapsed, briefly, with the end of the First World War. But meanwhile there was money in broom straw, which as its name implies was used for making kitchen brooms. Additionally, the Cherrys kept laying hens and a flock of turkeys. More importantly, they got into the dairy business, building a herd of nearly forty Holsteins whose fodder was the above-listed milo maize and sorghum. Did the Cherrys become rich? No. But as we shall see, they became prosperous, quite comfortably so.

An undetermined but very large majority of homestead couples had children, but childrearing duties did not prevent mothers from contributing to the homestead enterprise. Women commonly operated farm machinery, although before the advent of gasoline-powered equipment, they more often left this heavy work to their husbands and the several hired men who were often required on horse-powered farms.

Florence Bunch Isler, who with her husband Clyde emigrated from Tennessee to the prairies of eastern New Mexico in 1908, was a typical homestead wife and mother. The care of her husband, their four children, the vegetable garden, and the poultry took up most of Florence's time, but their house was also known far and wide as the "Isler Hotel." Nearly every day of the year, Florence set table for assorted young bachelors, who, far from home, longed for family. Many of them "worked off" their meals or paid whatever cash they could afford. But reimbursement was not Florence's intent; her meals and mothering were her contribution to the social welfare of homestead Quay County. The "Isler Hotel" did not survive Florence, for among other reasons the next generation of Isley wives and mothers were occupied with driving the family tractors and grain trucks.

Not uncommonly, homestead wives and mothers were often put to the test of carrying on without their husbands. The rural men and women with whom I talked affirmed that bad marriages and unhappy families were unusual, and that divorces and desertions were rare. Rather, I am referring here to homestead widows. The story of Hattie McReynolds Gjerde is typical.

Arriving in Montana from Norway in 1915, John Gjerde—with very little money and hardly a word of English—saved his wages, married the Montana-born, Scotch-Irish Hattie, and settled down to growing sheep in Park County (Plate 34). Tragedy struck in 1935, when alone in their Model-T Ford, John was

killed when it overturned on an icy road. Left with their three children, ages 7 to 11, the 45-year-old Hattie had no business training, nor was she more than casually acquainted with the requirements of successful sheep growing. But she learned the business end of the venture quickly, becoming the new, and much admired, boss of the herders, all the while rearing the children to successful adulthood.

The Gerings, whose homestead was situated on the sagebrush barrens of Adams County, Washington, 1,200 air miles northwest of the Cherrys' farm, are another family who made a success of commercial farming. Descended from German-speaking Swiss Mennonites, the family's history over the previous 250 years included displacements, persecutions, and other adventures that carried them from Switzerland to France, to Poland, and to the Ukraine. Finally, in 1888, Joseph Gering (Göring), the patriarch of the family, in the company of several other Swiss Mennonite families, arrived in Clackamas County, Oregon. After his arrival, he heard that some earlier Mennonite families had pushed on even farther, to Adams County, Washington, where it was said there was money to be had in wheat (Plate 35). The rumor prompted Joseph to send his grandson Adolph on a prospecting trip, and Adolph's favorable report resulted in the Gerings joining the Adams County people in 1900.[1]

In those years, nearly all of the prairie lands of eastern Washington, some 24,000 square miles, were in native big sage (see Campbell 1997a, xi). The land was watered exclusively and directly from the sky, and averaged from less than 6 inches to about 15 inches per year, depending on location. Most of these prairies are at low elevations: the Gering farm lay at 1,300 feet above sea level. The low elevation, when combined with local rain, snow, and temperature patterns, allowed the Gerings a growing season of 180 days, long enough for profitable wheat farming, even in the face of a miserly annual precipitation average of 12 inches. Wheat, however, was the only possible cash crop. Unlike the case of Union County, New Mexico, with its several agrarian options, in Adams County, Washington, if you did not grow wheat, you could not be a farmer. Practically speaking, the dry Adams County landscape offered nothing else in the way of cash cropping. So, for the Gerings and tens of thousands of other homestead families scattered across the prairie west, the necessity of farming wheat posed the problem of acquiring the extraordinary acreage necessary to make money with that crop.

For while the Cherrys and their neighbors got along very well on their few-hundred-acre diversified dry farms, the wheat grower needed thousands of acres to make good. Moreover, wheat, like corn and most other grains, depletes the soil, so that each year, on average, half of a wheat farm must lie fallow, its stubble plowed under and the fallow fields left to the elements to regenerate their fertility. Taking all that into consideration, the homesteader needed something like 5,000 acres, nearly 8 square miles, of land in order to make a profit—a situation as true today as it was then.[2]

Within ten years of their arrival, the Gerings, helped by their neighbors and their church, had saved enough money to acquire the necessary acreage, both by purchase and homesteading. While they saved, they got by with the usual meager homestead necessities, living in a small frame house of the sort described in Chapter 2 and subsisting on home-grown beef, hogs, milk, eggs, and the produce of their kitchen garden. The Gerings, like the Cherrys, if they did not become rich, became comfortably prosperous.

Affluence was most often expressed in practical and modest ways, as it still is today among the homesteaders' descendants.

Those who have remained on the land today are most commonly ranchers, not farmers, but they live in much the same style as did their parents or grandparents. Back then, an automobile might be called a luxury (Plate 36). Moody Cherry bought his first car, a Model-A Ford sedan, in 1927, and Adolph Gering bought his, a Ford touring car, in 1916. Both were purchased new, and both were paid for in cash. For most western homesteaders, buying "on time" was to be avoided. Indeed, it was considered unacceptable.

Among prosperous farmers, their "first" houses (described in Chapter 2) evolved into "second" or "third" houses. Single-story dwellings grew to two stories, normally with five to seven rooms. These larger dwellings exhibited a larger variety of styles (Plate 37). In Divide and Williams Counties, North Dakota, whose homesteaders were largely Norwegian immigrants, the houses tended to have two stories and were designed with a certain Scandinavian cast, although here, as elsewhere, the interior furnishings more than the exterior design tended to reflect national origin. Indeed, farmhouse architecture in the homestead West seldom reflected ethnic derivation, and so external house configurations varied little from one region to another.

I have noted that on the southern prairies houses were built commonly of adobe bricks (Campbell 1996, 15 and plate 18). It is also true that in two western regions, one may note the ethnic or geographical origins of pedimented and hipped roofs. Still, across the West the use of these designs had little relationship to the cultural backgrounds of the homesteaders who built them. For example, on the plains of southeastern Colorado and New Mexico, hipped-roof houses of adobe brick were built and occupied both by homesteading "Anglos" of diverse backgrounds, and by Spanish Americans. And even among the insular Swiss Mennonite farmers who settled Adams County, Washington,

homestead dwelling architecture conformed closely to a typical western prairie type.

With the exception of the occasional big, imposing houses, such as those shown in Plates 38 and 39, the most common second or third house, while often containing two stories, was a rectangular structure nearly identical in design to the small, one- or two-room, gabled-plain or hipped styles described in Chapter 2, except that these houses now contained two or more bedrooms, a kitchen, a dining room, and a parlor.

As noted in Chapter 2, some of these good, made-to-last, houses were constructed of locally available materials, but as farms prospered, most of them, both north and south, were constructed of milled lumber. Nearly all were built (as was also the case for the barns described below) with the help of local "experts"—farmers and skilled amateur contractors or architects—but some were mail-order houses (usually from Sears and Roebuck), shipped in their component parts from Chicago to the nearest railroad station, then put together by their owners or hired help. These houses ranged in price from about $900 to more than $5,000 (the latter bought usually by well-to-do town dwellers), and many remain occupied to this day (Plates 40, 41).

Not counting pantries, washrooms, and the like, the Cherrys' second house, built in 1918, had six rooms, including two bedrooms. The Gering's second house, built in 1916, had nine, including five bedrooms. Washtubs and sinks, sometimes with piped-in water, were common in such houses, but few had indoor toilets until the 1930s or later (see Plates 42, 43, 44). As the prosperity of homesteaders increased, they sometimes sought to build churches and barns that would reflect their ethnic origins (see Plates 46, 47). These farmers were churchgoers, and for both Protestants and Catholics a magnificent prairie

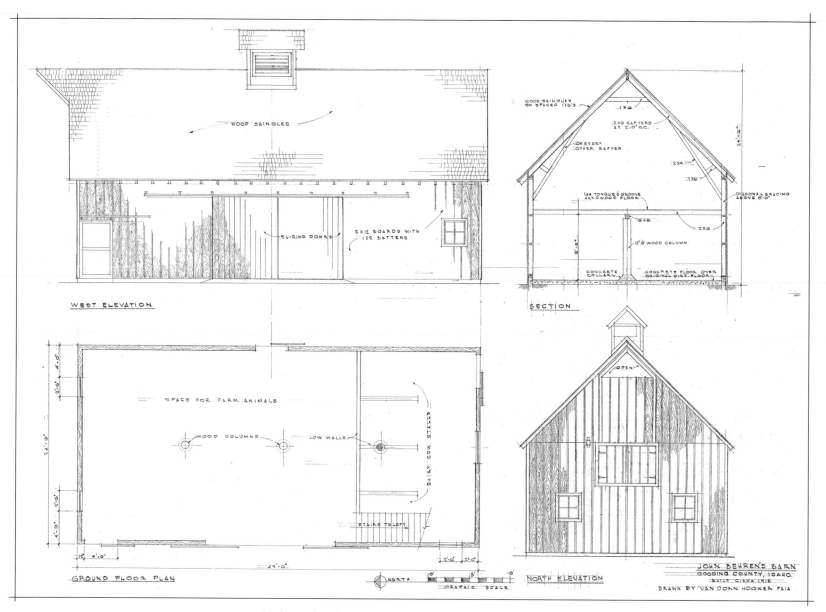

WEST ELEVATION

WOOD SHINGLES

SLIDING DOORS

2x12 BOARDS WITH
1x2 BATTENS

SECTION

WOOD SHINGLES
ON SPACED 1x6'S

1x6

2x6 RAFTERS
AT 2'-0" O.C.

ON EVERY
OTHER RAFTER

2x4

1x6

1x4 TONGUE & GROOVE
HARDWOOD FLOOR

DIAGONAL BRACING
ABOVE 8'-0"

2x6

2x6

11" Ø WOOD COLUMN

CONCRETE
COLLARS

CONCRETE FLOOR OVER
ORIGINAL DIRT FLOOR

GROUND FLOOR PLAN

SPACE FOR FARM ANIMALS

WOOD COLUMNS

LOW WALLS

DAIRY COW STALLS

STAIRS TO LOFT

NORTH

GRAPHIC SCALE

NORTH ELEVATION

OPEN

JOHN BEHREN'S BARN
GOODING COUNTY, IDAHO
BUILT CIRCA 1915
DRAWN BY VAN DORN HOOKER FAIA

GABLED-PLAIN STYLE, *circa 1915*. Among the five styles I have identified for the western homestead standard barn, the most common was the gabled-plain style. In this style, external lines and framing are nearly identical to that of the traditional European-American house, a dwelling type that was the universal favorite of the western homesteaders. In our sample of 2,668 standard barns, 1,374 had been built in the gabled-plain style. Note the recent addition of a concrete floor to this 85-year-old Idaho barn.

church represented Christian commitment and gratitude and often testified to their native origins.

If not for precisely the same reasons, the evolution of homestead barns, from humble to grandiose, followed a similar course. On the farmlands of eastern Washington where this writer was reared, there was an adage that said that a large barn and a small house meant the husband was boss, whereas a large house and a small barn meant the wife wore the pants. In fact, nearly all farmhouses were modest, and most all barns were large—this, despite the fact that there were a good number of strong-minded farm wives in Yakima County.

Big barns stood witness to necessity and, to a degree, pride. During the early decades of the era, horses were essential to farming, and the more successful the farmer became, the more horses were needed. Then, every successful farm also had other livestock, most commonly a milk cow and beef cattle, but often hogs and lambs, and always chickens or other fowl. The horses and cows required hay, the smaller animals other kinds of fodder, and all of them, large and small, required shelter of one kind or another.

Accordingly, and also because certain machines and vehicles and other artifacts also needed protection from the elements, the typical progressive western homestead barn was of a single "standard" type, to be differentiated from barns of specific purpose, such as apple barns, cattle barns, and dairy barns (see Plate 48). Derived from the simple, generalized type described in Chapter 2, but larger and more elaborate, it was built in five principal roof styles: gabled-plain, Dutch colonial (gambreled), western classic, arched, and saltbox (see drawing of barn, pg. 27, and Plates 49–55, 46).[3] In our travels we counted a total of 2,668 barns of this standard type, nearly all of them built between 1890 and 1930. Among them, the gabled-plain and Dutch

colonial styles were by far the most common, with the western classic, arched, and saltbox roof designs trailing, in that order.

Most surviving examples of the five styles are large. They average 41 by 46 feet in external plan, and 25 vertical feet from ground to ridge. Except for their roof lines, all are identical in basic design (with the exception of the saltbox).[4] Regardless of roofline style, all standard barns are two-story structures, with the ground floor containing several partitions and the upper story consisting of a single large room—a loft or hay mow. This loft, floored with wood, was designed especially for hay that was to be pitched to livestock below through open hatches lining each of the walls of the barn's long sides (Plate 51).

Much or most of the lower level was open, usually had a dirt floor, and was designed to shelter wagons and other wheeled vehicles. There were stalls or compartments of various sizes for housing livestock and bagged fodder such as oats at one or another end of the floor, or along one or both of the barn's long sides. The inner walls of the lower level served as storage space for an impressive array of small farm artifacts, from harnesses to handsaws, that required protection from the weather but did not belong in the house; these were hung from pegs and nails affixed to the walls (see Plate 55).

These made up the standard barn's practical components, but there were also embellishments. More than half of the barns we saw contained, variously, roof dormers, blind windows, decorative doors, pedimented eaves, or cupolas (Plates 23, 54). One or more cupolas astride the central ridge and opening into the loft was the most common adornment observed. They were a practical addition, since they let fresh air into the hay, thus encouraging dryness. But the other adornments were frosting to further enhance the look of these tall barns, which, looming for miles across the prairies, proclaimed their owners' prosperity.

Of the estimated seven million men, women, and children who participated in the western homestead era, some five million of them failed in the attempt. Reasonable, and if anything, conservative, this figure is nevertheless misleading since it includes an unknown but large number of would-be homesteaders who did not give the enterprise an honest try. For example, thousands of "homesteaders" filed for claims, had second thoughts, and quit without ever plowing even a square yard of ground. A similar number, commonly citified dreamers, not unlike the hippies of the 1960s, failed within weeks or months of trying their hand at homesteading, mainly because they had not the foggiest notion of what farming was all about. Still, an impressive majority of those who failed were farmers of experience and serious purpose—men, women, families whose intentions were to make homesteading a lucrative business. Many of whom "proved up" only to be "starved out," as the phrase went, later. There were two principal, and interrelated, causes for their failures: the lack of sufficient land and the lack of sufficient water.

We saw in Chapter 3 that the Gering family's success at wheat farming hinged upon the acquisition of several square miles—some 5,000 acres—of cultivable land. To this day, the Gerings and their neighbors remain successful wheat farmers, as are thousands of other dryland, wheat-growing families in various parts of the West. But in each case, these successful farms are, on average, thirty-two times the size of a 160-acre homestead. Half or more of all west prairie homesteaders found, as did the Gerings, that wheat offered the only option for a successful crop on their lands. But given the limitations of the homestead legislation, only a tiny fraction of these farmers were able to acquire the necessary acreage to grow wheat profitably. Thus emerged across the prairies a pattern of ruin, based simply, it would seem, on too little land per homestead, and affecting an impressively large farm population. But for

what reason was 160 acres—or three or four times that much—not enough land? The term *dry farming*, as noted earlier, refers to crop-growing (usually in arid lands) without artificial irrigation, the ever-essential water deriving from falling rain, or snow, or both. And to use the term broadly, a Connecticut "dry farm," for example, of 160 acres of apples, can make its owner wealthy because, among other reasons, a Connecticut orchard receives each year upward of 45 inches of water from the sky.

In the case of the Cherry family, they did very well on their square mile or so. Even today, on the prairies of Dolores County, Colorado, if you own 640 acres of dry-farmed pinto beans, you are well-to-do; in the past few decades, 640 acres of dry-land pinto beans would have brought $640,000 at market. Size, then, was not the key to success for western dry-land homesteads; here, a farmer could be ruined by lack of water (see Plates 59, 60). Although there may have been ancillary causes, it was drought, in one or another implacable guise, that was the principal agency of western homestead failures. These failures were all the more bitter since the effects of drought were often unknown and unanticipated by the settlers, most all of whom were immigrants from far less arid climes.

My father, John, and one of his brothers, "Bonny George" Campbell, were among these immigrants. Born, reared, and taught the art of farming on a successful, diversified half-section among the hills of east Tennessee, in 1911 the two of them filed and took up dry farming on a grassy bench overlooking the Boulder River in Sweetgrass County, Montana. But good farmers that they were, they did not take into account the fact that the prairies of south-central Montana and the misty valleys of Tennessee have astonishingly different climates. Most particularly, they were ignorant of the notable difference in annual precipitation. At their Tennessee farm, precipitation averaged 54 inches a year; at their homestead on the bench above the Boulder, it is 15 inches. If you then consider that the Tennessee farm lay 900 feet above sea level and the Montana place lies more than 4,000 feet above the sea, and that the difference in latitude between the two locations is 10 degrees, you will begin to appreciate why the brothers Campbell went broke in less than two years.

For my father and his brother, however, their misadventure was hardly catastrophic. In their mid-twenties, unmarried, and college-educated, they still had plenty of other prospects. To them, the West of 1911 was a splendid adventure—so much so that they remained westerners for the remainder of their lives. There were thousands of others just like them—young farmers, energetic and unencumbered—who also failed and emerged none the worse for wear. Their experiences are not to be compared, however, with those of the multitudes of others: families, not free-roaming bachelors, who staked their last bit of cash on dry-land homesteading and within a few years lost everything. The hardships suffered by homesteaders in Harney and other southeastern Oregon counties (Plate 3) over a span of ten years beginning in 1910 were typical. This classic landscape of big sage in the northern reaches of the Great Basin Desert is fertile ground (see Allen 1987, Ferguson and Ferguson 1978, Hatton 1977, and Houghton 1986). Composed of humus generated by its native flora, together with volcanic ash and alluvial and wind-deposited sands and silts, its soils are not the same as those of the shortgrass prairies, but they are at least as rich. From northern Nevada and Utah northward to the Canadian border, the region promises as good farming as one could wish for. Still, in southeastern Oregon, disaster struck. Drought, again, was the chief cause of the region's ruin, but as it happened, it was drought of a peculiar, stealthy nature.

The most recent of the major North American glacial episodes, the so-called Wisconsin Glacial Stage, ended about ten thousand years ago. Since then, the open lands of the West have been slowly drying out, but the decline from wet to dry has not been uniform or steady. To chart it with pencil and paper, one draws a descending line that is wavy, not straight. The tops of the waves represent intervals, ranging from a few years to several decades or more, during which precipitation has been more abundant. These years of abundance have always been followed by drought, however, which is represented by the nadir of the waves on the line (see Fleck 1997; Taugher 1966). Science has not yet been able to explain these relatively brief periods of wetness that are followed by relatively longer periods of dryness. Regardless, the advent of the twentieth century brought good years to the prairies, years of generous precipitation. From the standpoint of western homesteading, however, the timing of this abundant rainfall could not have been worse.

The reader will recall that the years from 1900 to 1911 or 1912 were the peak years of western homesteading, with hordes of farmers pouring in from Europe and points east and south within the United States. Further, as noted in the Introduction and Chapter 1, the federal government had chosen to ignore or gloss over the advice of such expert observers of the landscape as John Wesley Powell. Powell and others had been saying for more than a decade that most of the western open country was far too dry to farm. The question of whether western newspapermen, railroaders, land surveyors, "land locators" (promoters), and other parties with a vested interest in western land sales were privy to and understood such warnings remains open, but certainly few of the homesteaders who flocked to the West were aware of the experts' opinions. To many of them, the open lands of the Oregon desert seemed plenty good enough for dry farm-

ing. It was a rich countryside: in only a few days one man with a team of horses could turn under 10 acres of sagebrush, and the range of seemingly possible dry-land cash crops included corn, wheat, barley, oats, potatoes, and even peaches. Hundreds of families rushed to file their claims for this rich Oregon land.

The cattle and sheep men who were there first, and who had freely grazed their herds and flocks on what was now fast becoming farmland, sided, not quite innocently (since they were following their self-interest), but correctly, with the academic experts who claimed that the land could not be farmed without irrigation. But, as described by Hatton (1981), between 1902 and 1912 precipitation in this reach of sagebrush was good, averaging 14 inches per year. The homesteaders were not to be denied. Farms, towns, post offices, roads, and schools were established within months of the homesteaders' arrival, even though proving up was still several years down the line.

There were complications from the beginning. One major problem, purely fortuitous, was jackrabbits. As bad luck would have it, most of the Oregon homesteaders arrived during a population explosion of these big prairie hares that were able to mow down entire fields of seedlings as soon as they had sprouted. And then, just as Mother Nature (and an all-out war between the homesteaders and jackrabbits) was getting the problem under control, the rains and snows petered out. As the drought progressed, potatoes, if they grew at all, were the size of golf balls, wheat sprouted but would not head, fruit trees died as saplings. By 1917, average annual precipitation had fallen to 4 inches, close to where it remains today, and the schoolhouses, post offices, and mercantile stores, all nearly brand new, sat abandoned.

This catastrophe had its analogues elsewhere on the prairies, in failures that approximated the Oregon collapse, even if they were not commonly within the same time frame. In each region,

sudden drought reduced thousands or tens of thousands of farm families to abject poverty.

An incident related to me by the eminent anthropologist Jesse Jennings is illustrative. Dr. Jennings was one of America's best-known and most-respected anthropologists. One spring weekend in 1954, after I had gotten back from the Korean War and resumed my schooling at the University of New Mexico, Professor W. W. "Nibs" Hill showed me a derelict homestead in Torrance County, New Mexico, where, he said, the distinguished Dr. Jennings had been reared in the 1920s. Later, I was privileged to meet Jesse Jennings, and by way of opening a conversation I told him how interesting it had been to see his family's old farm. I still remember the unhappy reply of that middle-aged man who still looked like a rangy farm boy, and after all these years, I can quote him word for word. "Campbell," he said, "when we arrived on that place, we came in two big wagons, each pulled by a four-horse team. And when we left that place, we walked."

There was much worse, of course. In Weston County, Wyoming, rancher Pete Smith pointed out to me recently the ruins of a homestead cabin in which two small boys had died of exposure, suffering from want and cold in the face of a deteriorating climate. Less tragic, but nevertheless catastrophic, is the story of the end of farming in Union County, New Mexico.

Taking up again the story of the Cherry family (and of thousands of their neighbors), by 1927, the year Mr. Cherry bought his first new Ford, homesteaders had plowed every bit of the land in the county that was plowable, and for three decades or more, annual precipitation in Union County had averaged a benevolent 18 to 20 inches. Flourishing towns included Grenville, Gladstone, Clayton, Sofia, and Mount Dora, and while there was no such thing as a paved road, every sizeable settlement had its rail connection to the outside world. In 1921 Union County's total pop-

ulation stood at 11,680, and Clayton, its county seat, contained the infrastructure necessary to any burgeoning small city. By any measure, this was prosperity, and it was based squarely on dry farming (see Campbell 1997b).

Disaster came practically without warning. By sheer coincidence, the Great Depression and a totally unexpected and severe decline in rainfall struck at the same time. Through much of the 1930s, as the deadly drought settled over the prairies, what few crops there were went begging for lack of markets. The disk plow and the harrow (Plates 27, 28) had been principal tools of cultivation on the Great Plains, including the shortgrass prairies. The blades on these implements turn the soil in such a way that, unless the ground is moist, the resulting broken and pulverized clods are susceptible to wind. Thus was created the Dust Bowl, with its black skies in the middle of the day, and its cash-crop soils piled in dunes against the fences.[1]

But even without the destructive farm machines and the economic depression, year after year of drought would have ruined the farmers anyway. From an average of 18 to 20 inches of rainfall a year, precipitation in Union County fell to 11 inches in 1931, and for years afterward the annual mean was little more than 9 inches. As is the common lot of farmers, even the more successful ones, they are dependent on bank loans to help see them through the annual growing season. Each winter Union County homesteaders—most all of them owners of substantial farms—would take out loans on the following year's crops, using as collateral the prospective crops themselves, as well as real property or farm machinery. Until the 1930s, the farmers of Union County enjoyed a vigorous economy. They were able to pay their loans on time, and frequently there was cash left over. But then came the drought. Like their neighbors, the Cherrys suffered through some of the early bad years, but it got to where

not even milo maize would grow, and it is a crop that can withstand prolonged dry weather better than most. Moody sold his dairy herd for want of fodder, and his bank loans went unpaid. He, like his neighbors, got caught up in the double spiral of ever-decreasing productivity and ever-increasing debt, until, in the end, Union County farming collapsed totally and for good (Plates 69, 70).

The population of Union County today is 5,000, and many residents are newcomers, living in the railroad and hub town of Clayton. Precipitation seems to have stabilized at about 10 inches a year. Except for a few localities that are watered from deep wells, there is not an acre under plow in all of the county, and that is why the blue grama and the pronghorns and curlews—all but the buffalo—are back. And why, if you are not up on your Union County history, you will think that, except for the cows and the cowboys, the landscape here looks just as it always has.[2]

Plates

Plate 1

Shortgrass Prairie
Union County, New Mexico
1999

Every foot of the 50 square miles or more of rolling green prairie shown here was homesteaded in the first three decades of the twentieth century. This landscape represents only a sample of the thousands of square miles of identical countryside in eastern New Mexico that were farmed during those years. These were the old shortgrass buffalo prairies of the westernmost Great Plains. Dominated by blue grama grass (*Bouteloua gracilis*), they provided for highly successful farming until ruined by the prolonged, deadly drought of the 1930s and 1940s. Now, the native grass has come back to provide marginal cattle grazing. The elevation is 5,000 feet above sea level.

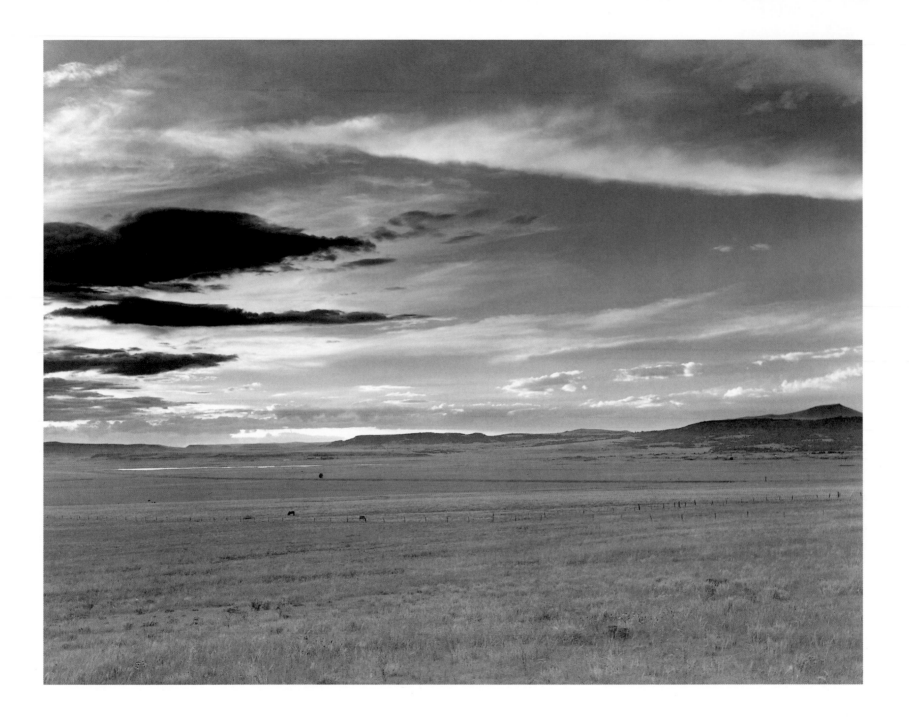

Plate 2

Homestead Patent
Valley County, Montana
1915

After three to five years of hard work at proving up, the attainment of a federally granted patent was a joyful occasion. For countless thousands of homesteaders, and especially for recent immigrants from the fiefdoms of Europe, it marked the first time ever of land ownership, with all the rights and privileges that accompany a free-and-clear deed. Some of the new owners chose to get out of the land business by selling, hopefully at a profit, but to many the dream of owning their own farms had come true. In this instance, President Woodrow Wilson's signature testifies to his participation in the western homestead era.

4—1004.

The United States of America,

To all to whom these presents shall come, Greeting:

WHEREAS, a Certificate of the Register of the Land Office at Glasgow, Montana,

has been deposited in the General Land Office, whereby it appears that, pursuant to the Act of Congress of May 20, 1862, "To Secure Homesteads to Actual Settlers on the Public Domain," and the acts supplemental thereto, the claim of

Juy N. Robertson

has been established and duly consummated, in conformity to law, for the southeast quarter and the north-east quarter of the southwest quarter of Section sixteen and the north half of the northeast quarter and the northeast quarter of the northwest quarter of Section twenty-one in Township thirty-seven north of Range forty-nine east of the Montana Meridian, Montana, containing three hundred twenty acres,

according to the Official Plat of the Survey of the said Land, returned to the GENERAL LAND OFFICE by the Surveyor-General:

NOW KNOW YE, That there is, therefore, granted by the UNITED STATES unto the said claimant the tract of Land above described; TO HAVE AND TO HOLD the said tract of Land, with the appurtenances thereof, unto the said claimant and to the heirs and assigns of the said claimant forever; subject to any vested and accrued water rights for mining, agricultural, manufacturing, or other purposes, and rights to ditches and reservoirs used in connection with such water rights, as may be recognized and acknowledged by the local customs, laws, and decisions of courts; and there is reserved from the lands hereby granted, a right of way thereon for ditches or canals constructed by the authority of the United States; reserving, also, to the United States all coal in the lands so granted, and to it, or persons authorized by it, the right to prospect for, mine, and remove coal from the same upon compliance with the conditions of and subject to the limitations of the Act of June 22, 1910 (36 Stat., 583).

IN TESTIMONY WHEREOF, I, Woodrow Wilson

President of the United States of America, have caused these letters to be made Patent, and the seal of the General Land Office to be hereunto affixed.

GIVEN under my hand, at the City of Washington, the SIXTH

day of JANUARY In the year of our Lord one thousand

nine hundred and FIFTEEN and of the Independence of the

United States the one hundred and THIRTY-NINTH.

By the President: *Woodrow Wilson*

By *M. P. LeRoy*, Secretary,

L. Q. C. Lamar
Recorder of the General Land Office.

RECORDED: Patent Number 452176

6—2192

Plate 3

Sagebrush Country
Harney County, Oregon
1999

The sagebrush country of the interior Northwest is a land of exceptionally fertile ground. Dominated by big sage (*Artemesia tridentata*), its soils consist of sage and grass mulch, volcanic ash, and various wind- and waterborne components accumulated over the past ten thousand years and more. Plow under the sagebrush, plant apples, wheat, or sweet corn—to name three of many possibilities—and so long as your crops have water, you can make a lot of money. Water was the problem, however. The elevation here is about 4,200 feet, the growing season is on average 77 days, though it can be as long as 140 or as short as 30, and average annual precipitation is 11 inches.

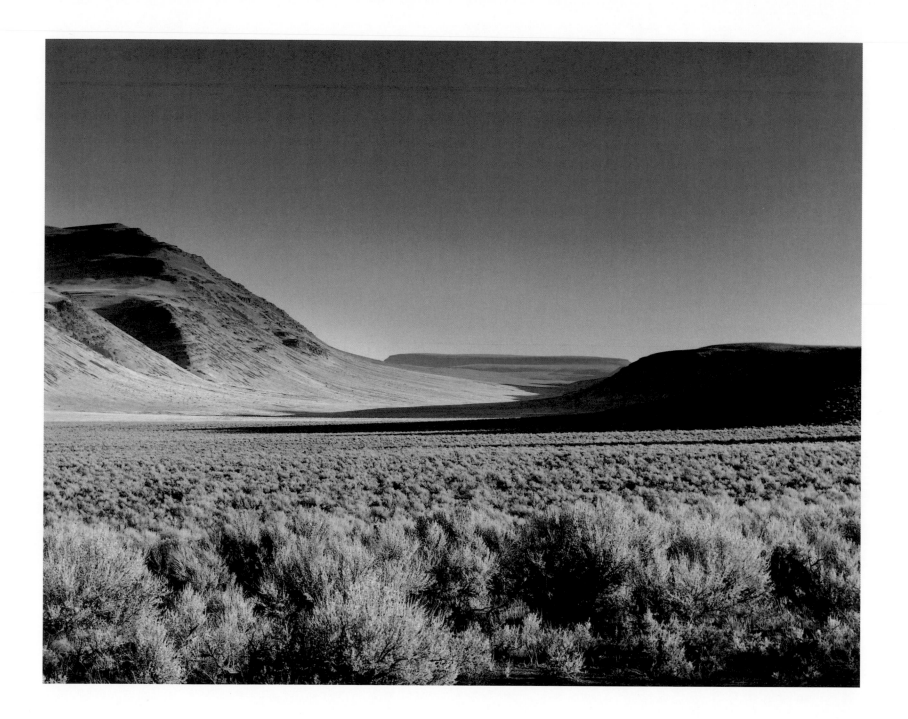

Plate 4

Loading Chute
Yakima County, Washington
circa 1915

A loading chute is an enclosed ramp used for loading and off-loading livestock from ground to truck, wagon, or rail car. Typically, its lower end reaches into a corral that opens onto a pasture or feedlot. Modern-day loading chutes and their corrals are of precisely the same design (if not always of the same materials) as they were more than a century ago. This chute and the overturned hay rake beside it belonged to John and Maude Fontaine, whose subsistence homestead is described in Chapter 1. The side boards of ponderosa pine are 12 inches wide.

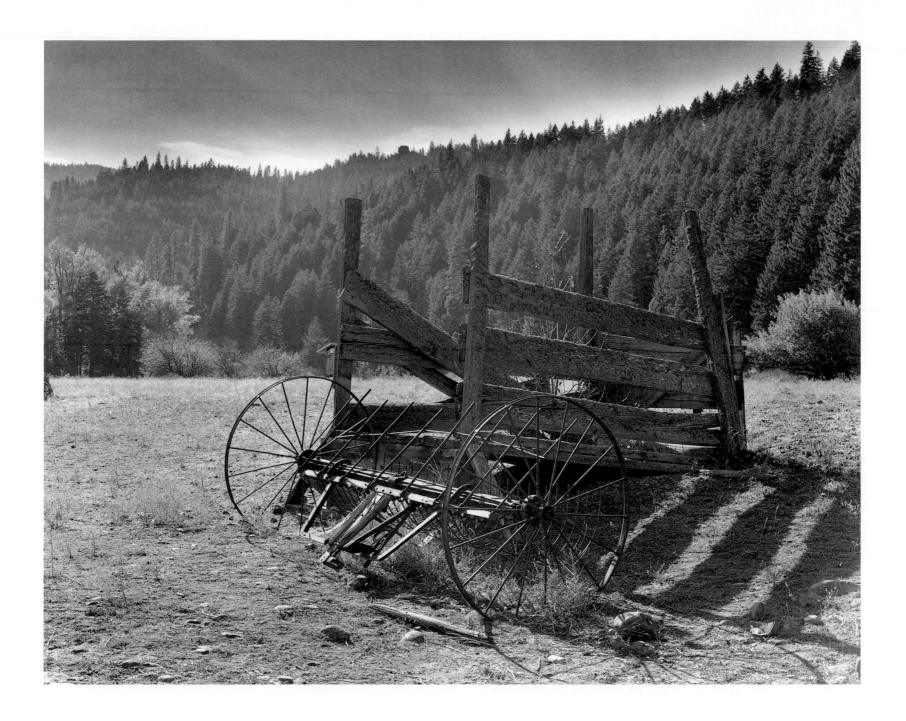

Plate 5

Buck Saw
Morrow County, Oregon
circa 1920

Among hand tools, a saw of one kind or another was next in importance after a knife and an axe. It saved untold hours of hard work that otherwise would have required laborious hewing and chopping, and the ubiquitous "buck," an all-purpose saw, was the western homesteader's first choice. A buck will cut anything, from two-by-fours to fence posts. Weighing about 3 pounds, with handles at each end, it worked faster if there were two sawyers, but sawed about as well for the lone homesteader. In this case, as shown at left, a homesteader had used it to trim the logs of his cabin. Length of the blade is 27 inches.

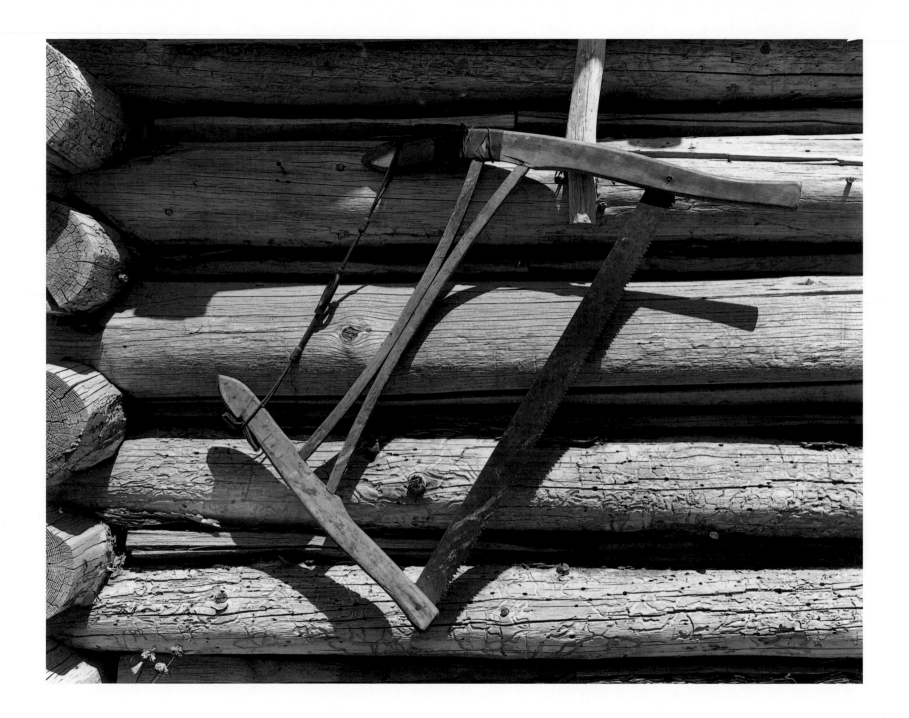

Plate 6

Coal Oil Lantern
Sioux County, Nebraska
circa 1916

Few homesteader artifacts were more dear than the kerosene, or coal oil lantern, as it was known across the West. Caged loosely in wire and carried by its wire bale, it would shine through rain, snow, and gale, or, perched on the kitchen table, illuminate all of a homesteader's first house. Lift the glass globe an inch or two, turn up the wick, light it with a kitchen match, and depending upon the model, it would burn for fifteen hours or more. This example is a Dietz, the most famous of lantern brand names, and it sold for about a dollar. It is 13 inches tall.

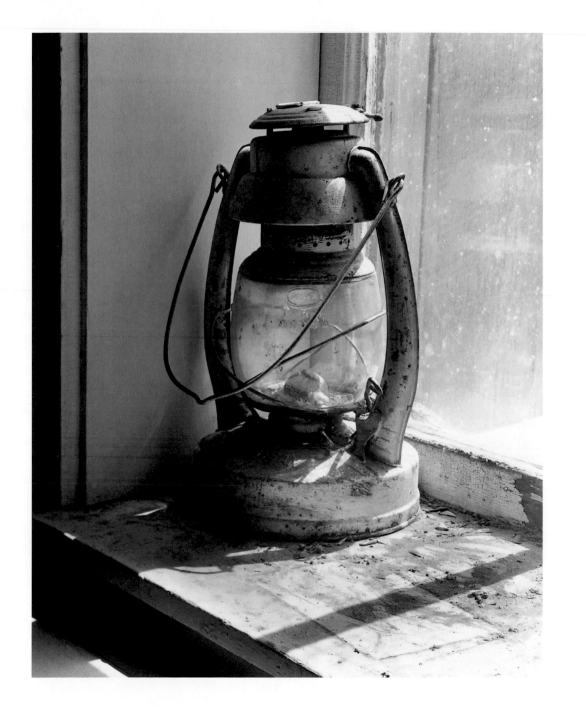

Plate 7

The Plow That Won the West
Park County, Montana
circa 1910

This simple, classic walking plow was the first sod-breaking machine of western homesteading. In hard ground it was pulled most effectively by a two-horse team, but because a saddle mount was sometimes the neophyte homesteader's only beast of burden, saddle horses, one at a time, served many a long day in harness. Thousands of western homesteads were proved up with the walking plow, even though with this implement it took all day to turn over a few acres of sod. Minus its wooden handles, the plow shown here weighs 60 pounds and its composite blade, consisting of the share (lower right) and the moldboard, is 32 inches long.

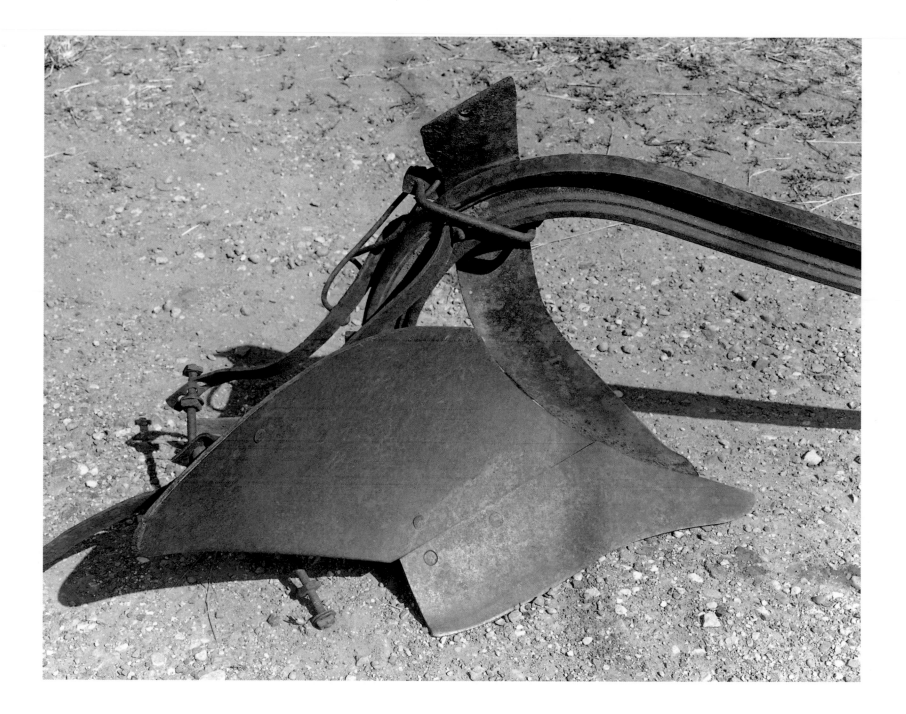

Plate 8

Grinding Wheel
Morrow County, Oregon
date unknown

In this writer's experience, the ubiquitous grinding wheel was the best of all farm implements, simply because it required so little work. As soon as your legs were long enough, you sat on the seat, pumped the pedals, and ruined the cutting edge of every sharp tool on the place. Still, in adult hands the grindstone was a universally valuable homestead tool. The wheel shown here is 17 inches in diameter and including frame, seat, and pedals, this example weighs 80 pounds. Before the First World War, mounted wheels of this type retailed for about three dollars.

Plate 9

Homestead Wagons
Meagher County, Montana
circa 1918

When the homesteaders went over to gasoline power, wagon boxes and beds were used for other purposes and workhorses were sold or put out to pasture. Wagon wheels, meanwhile, went to the farm dump, and most of those that have not rotted away now line the driveways of modern western town and country homes. This dump, on what is now a cattle and hay enterprise, contains what is left of the homestead farmer's wagons, whose models were designed for a variety of purposes. Outside diameter or "height" of each wheel shown here is 40 inches.

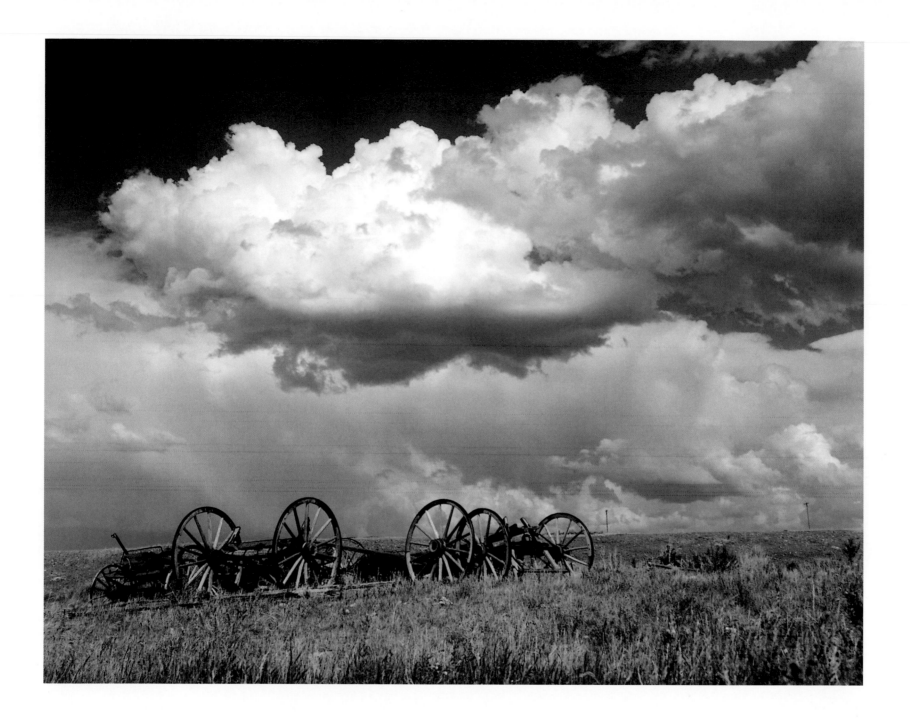

Plate 10

Nothing But Hay
Meagher County, Montana
1999

It is hard to imagine a more charming pastoral valley than that of the upper Smith River. The valley's narrow floor offers as good agricultural ground as anyone could hope for. When the first Norwegian and Scottish farmers arrived here in the late 1870s and early 1880s, the rich ground of the valley along with irrigation water from the river must have seemed like the answer to a homesteader's dreams. But there was a catch. Because of its elevation (4,400 feet above sea level) and its latitude (47 degrees north), nothing would grow but hay, which is why some Smith River homesteaders bought out their neighbors and went to raising cattle.

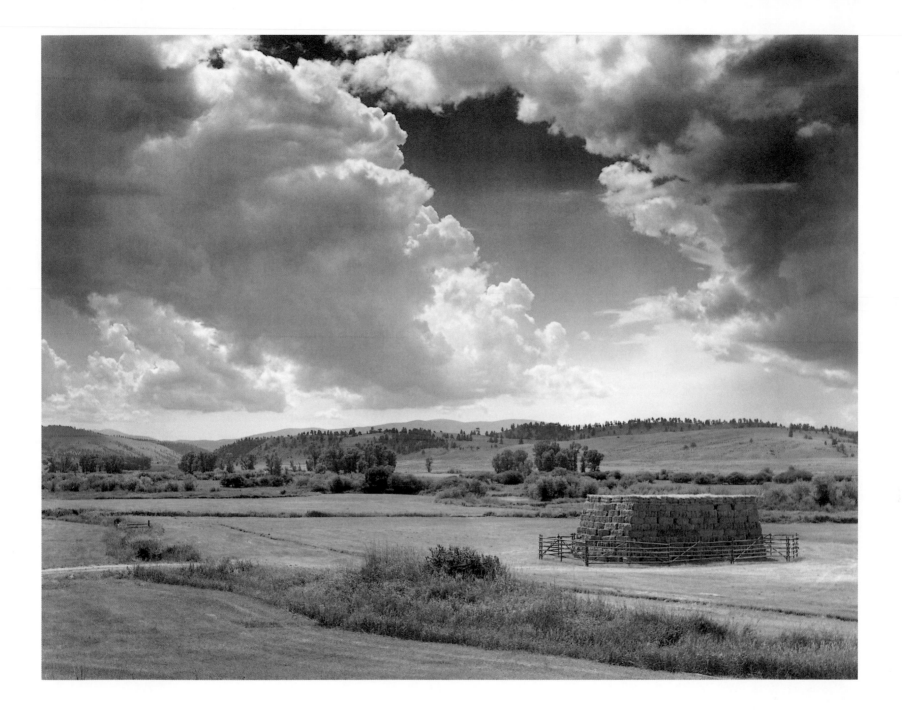

Plate 11

House and Barn
Colfax County, New Mexico
circa 1890

Of hand-squared ponderosa pine logs hauled in by team and wagon from the volcanic hills in the background, these two buildings are like thousands of other first "permanent" structures in the Homestead West. On the left is the one-room house, measuring 15 by 15 feet in external plan and having a flat roof of poles and earth. The other building, of identical design, hardly qualifies as a barn in the usual sense of the term, but was used to shelter livestock from high plains blizzards. Its external horizontal dimensions are 11 by 11 feet. The elevation is 6,800 feet above sea level.

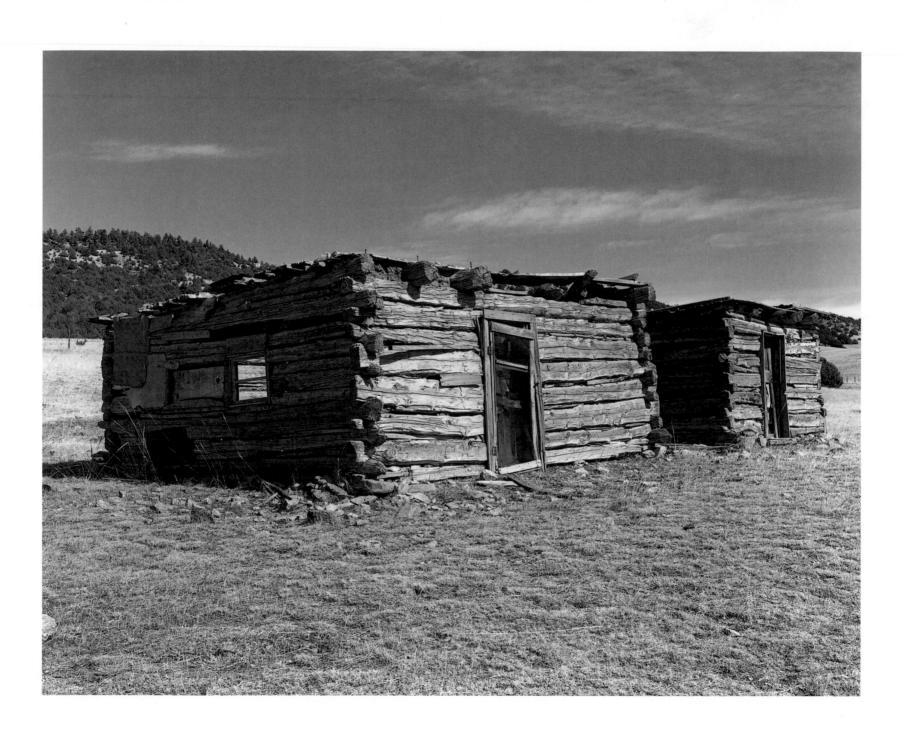

Plate 12

A North Prairie Dugout
Park County, Montana
circa 1915

In modern-day parlance, digging a hole in a cut bank was far more "labor intensive" than putting up a tent. And the arriving homesteaders were inclined to describe the work involved in more salty, but if anything, more enlightening language. A prairie winter, however, demanded more than a tent, and depending upon locale and other circumstances, dugouts, rude as most of them were, got thousands of homesteaders through their first western winters. This example seems to have served first as a dwelling, and then, with improvements, as a root cellar. Its door is 29 inches wide, and its roof logs average 9 inches in diameter.

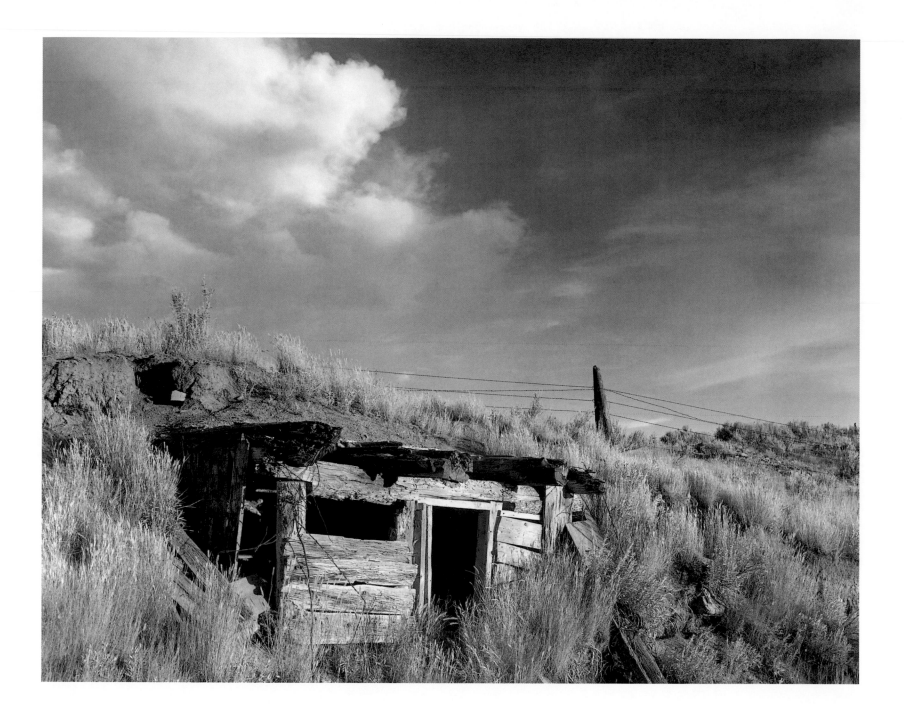

Plate 13

Dugout
Las Animas County, Colorado
date unknown

The homesteader's first prairie dwelling was often a canvas wall tent, followed in weeks or months by a second house, often so small as to suit only a bachelor man or woman, but far more substantial than a tent. Dugouts of several types and styles were common. This tiny, elegant example is no larger than many a modern bathroom, but it even contains an excellent little fireplace. Depth of floor at front is 4 feet below ground surface, and external width at front is 11 feet.

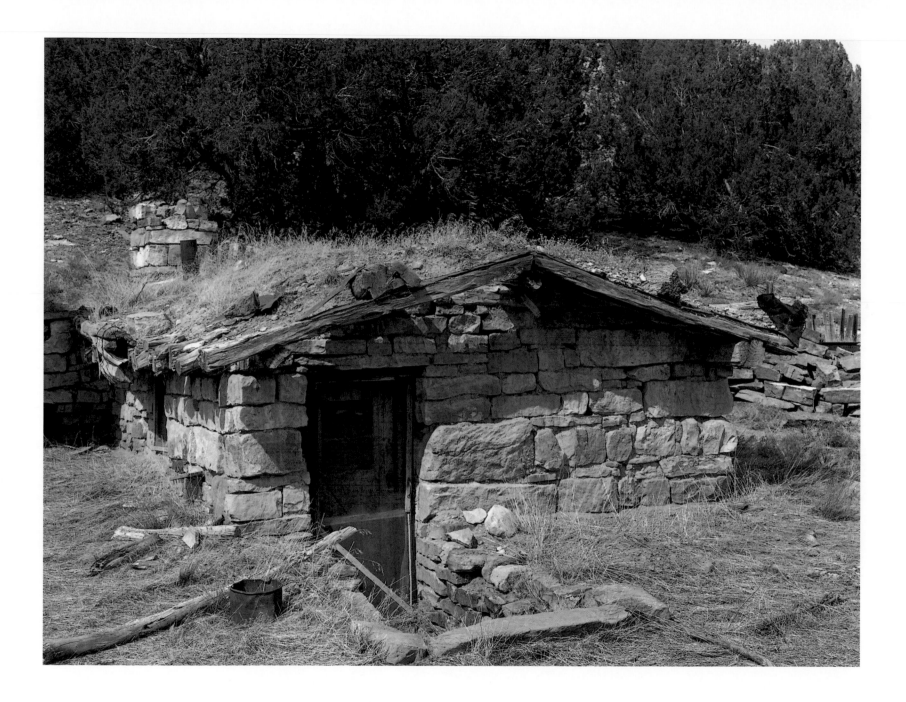

Plate 14

Adobe House
Harding County, New Mexico
circa 1915

This two-room dwelling of adobe bricks tempered with native buffalo grass is typical of hundreds of homestead houses that once occupied the prairies of eastern New Mexico. Half or more of them were of the hipped-roof style shown here, but with rare exceptions only those with walls of stone have survived; once the roof of an adobe house begins to leak, its walls melt into piles of mud. The few cottonwoods were planted by the homesteader near a little spring, and today they are the only trees for miles around. The house is 15 feet tall, its walls are 17 inches thick, and in external plan it measures 18 by 25 feet.

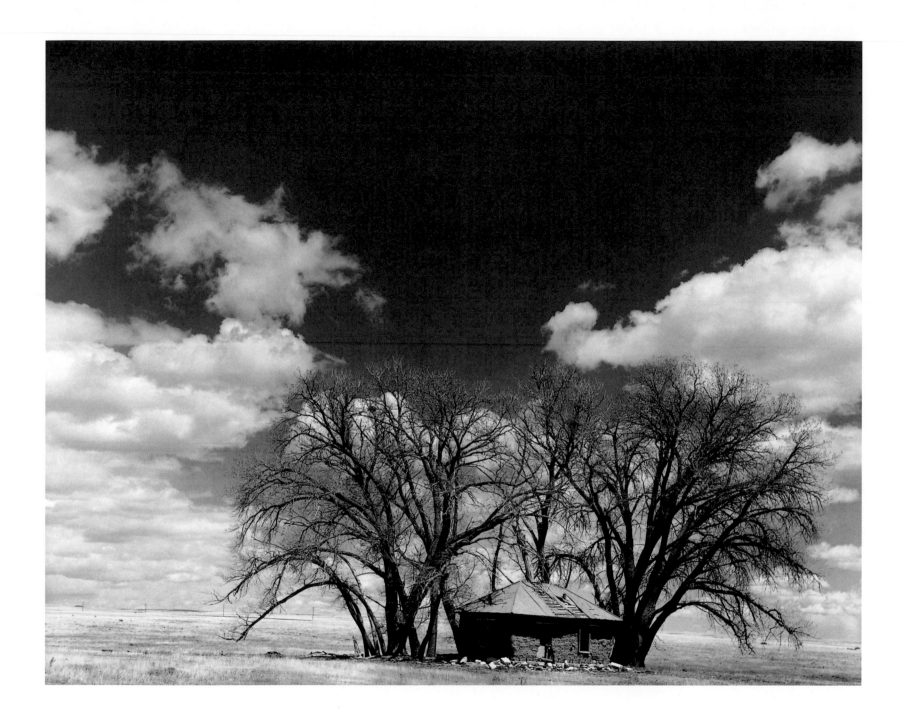

Plate 15

Adobe House Detail
Guadalupe County, New Mexico
circa 1900

In the adobe homestead houses of the southern prairies, window and door frames were prefabricated in box form at the building site, then nailed to blocks of wood buried in the adobe brick sides of the openings. Among the examples observed in our fieldwork, all such frames were of milled lumber, usually 2-inch by 12-inch pine stock of the kind shown here. The outer sides of these adobe walls are faced with thin, chiseled pieces of sandstone covered originally with half an inch of Portland cement.

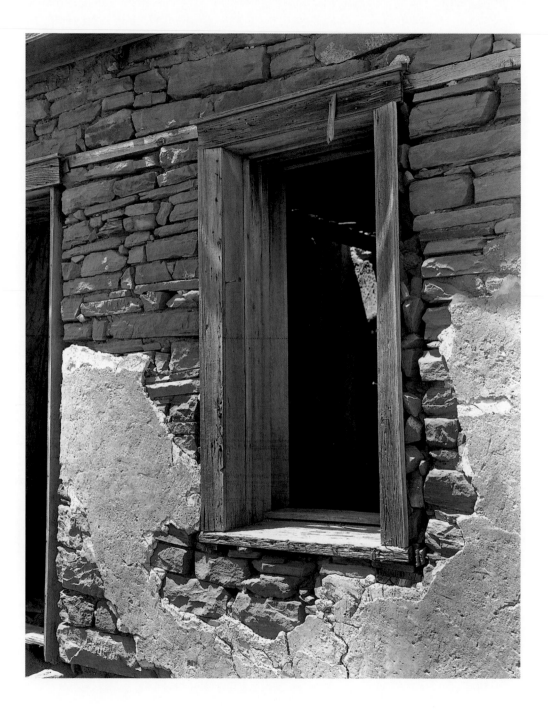

Plate 16

Stone House
Union County, New Mexico
circa 1915

Earliest homestead era houses were usually of one or two rooms, and were distin-
guished by two principal roof styles, a simple gable, as shown here, or one of several
hipped variations (see Plates 14 and 37). Over much of the southern prairies, house
walls were of native sandstone or limestone, laid with elegant precision and mor-
tared, most commonly, with mud. The walls of this two-room dwelling are 22 inches
thick, a characteristic that served to insulate the interior from both summer heat and
winter cold. Its external plan dimensions are 15 by 29 feet, and its height from ground
surface to ridge is 15 feet.

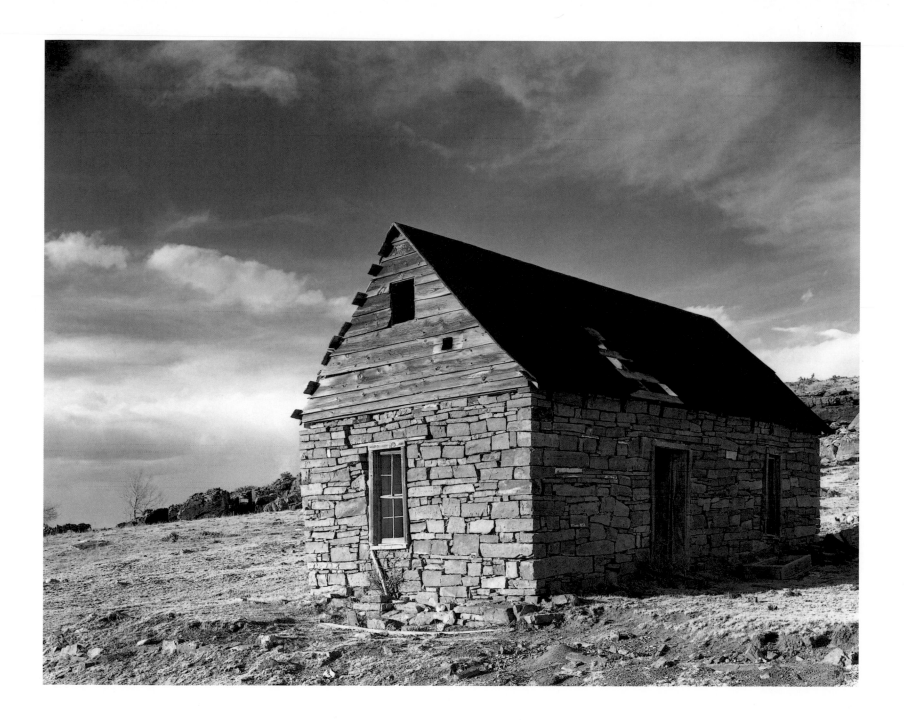

Plate 17

Log Cabin
Lawrence County, South Dakota
1890

When suitable timber was available, the western homesteader's first permanent house was the "Abe Lincoln"-type log cabin. Distinguished by a central gable running the length of its pitched roof, its walls were chinked with mud, moss, or whatever else was handy and effective. This one-room example made of hand-hewn logs remains nearly as sturdy and weatherproof as when it was built more than a century ago. Its external plan dimensions are 17 feet 6 inches by 20 feet, and its height from ground to ridge top is 14 feet.

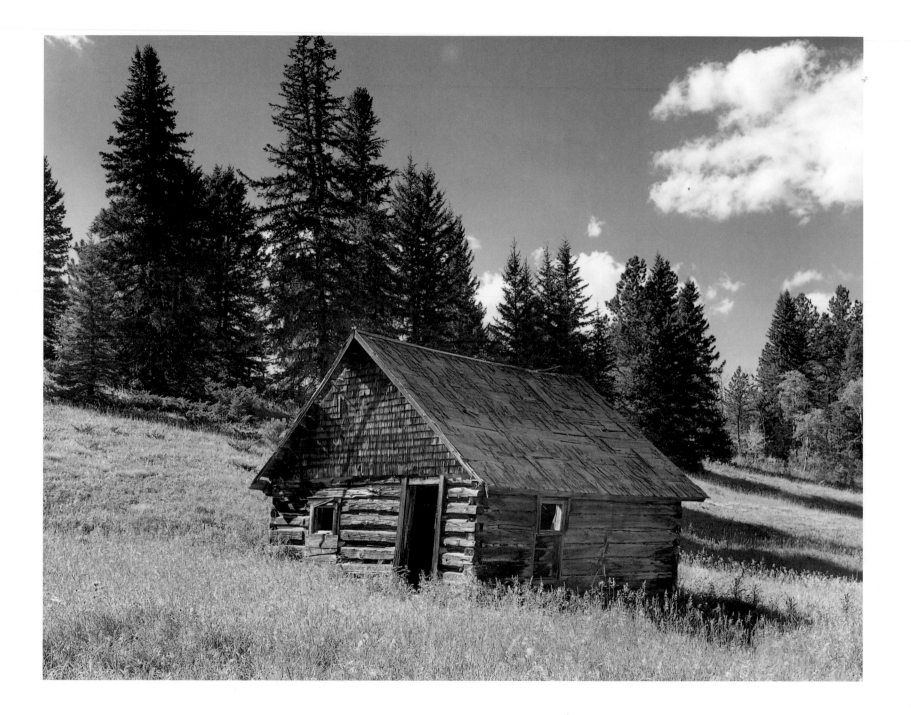

Plate 18

Gabled-Plain Frame House
Colfax County, New Mexico
circa 1910

This dwelling is the milled lumber counterpart of the stone house shown in Plate 16. Although their initial shelters were often canvas tents, nearly all of the homesteaders built their first more permanent houses in a style that conformed to an ancient pattern. To this day, this pattern remains the most common small-house type in most of rural Canada and the United States. It is a single-story structure, rectangular in plan, and has a pitched roof containing a central gable or ridge. There are seemingly endless variations of this type, the most common being room additions built at right angles to its long axis. This average two-room example is 20 feet long, 15 feet wide, and 12 feet tall.

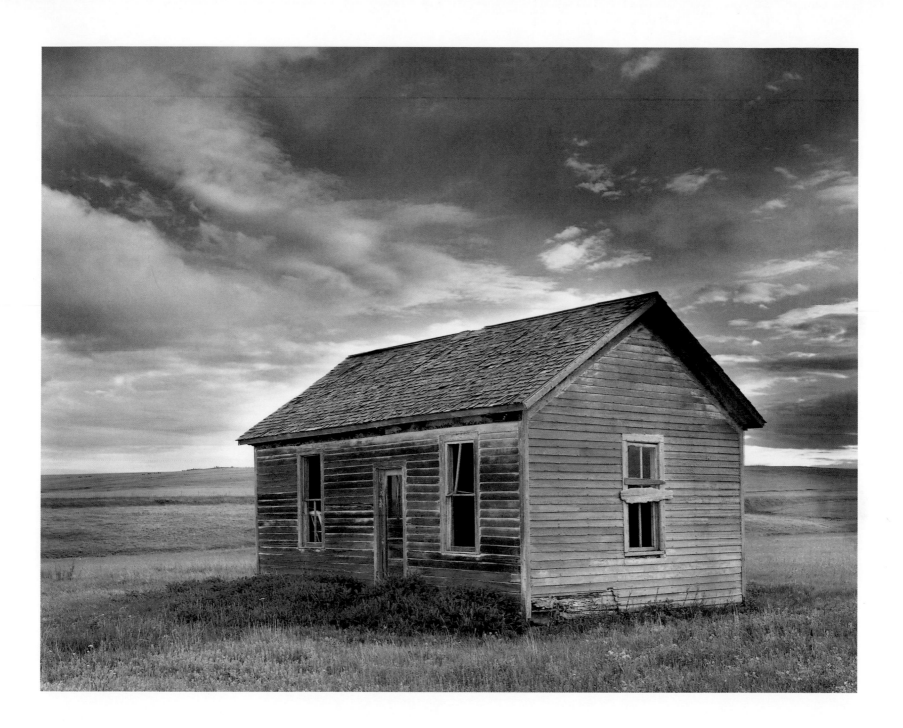

Plate 19

South Prairie Schoolhouse
Union County, New Mexico
1906

One-room schools in which the first eight grades were taught by one teacher were among the most common of western homestead buildings. In regions of numerous farms the schools were sited no more than 2 or 3 miles apart, and with rare exceptions their design and construction conformed closely to that of the prevailing style, or styles, of regional homestead dwellings. This example from the southern sandstone and limestone country is larger than the house shown in Plate 14, but its architecture, including its thick walls, is remarkably similar. Built of sandstone quarried locally, its walls are 18 inches thick. Horizontal plan dimensions are 26 by 43 feet, and from ground to ridge the house is 22 feet tall.

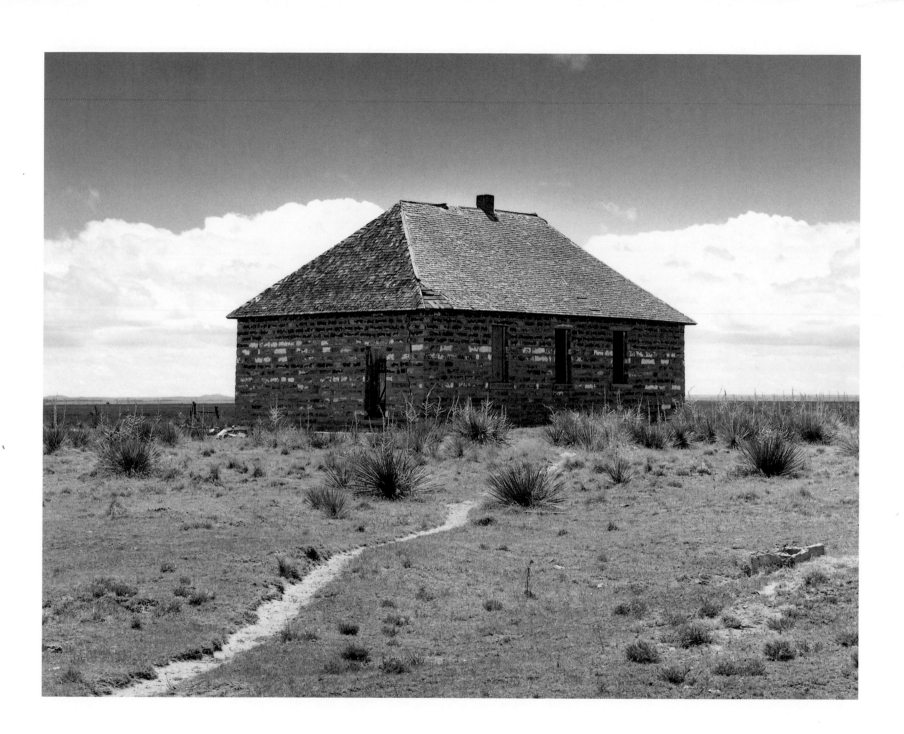

Plate 20

Methodist Episcopal Church
Gallatin County, Montana
circa 1896

The old army saying that there are no atheists in foxholes did not apply precisely to the homestead West, but it came reasonably close. Mortality from accidents and other causes was high. The nearest doctor was often a long day's ride away. Inoculations and vaccinations for such deadly and common diseases as typhoid fever and smallpox did not reach many homestead families until the 1930s. Churchgoing, therefore, was anything but a casually hopeful experience; for millions of farmers, it was one of life's imperatives. External plan dimensions of this small church are 22 by 36 feet, and it is 24 feet tall.

Plate 21

Windmill
Harding County, New Mexico
1915

Over most of the prairies, the only perennial source of domestic water—for both man and beast—quite commonly ran underground. Thus, of necessity, well-digging was among the western homesteader's more onerous chores. One good well, its water pumped by a wind-driven mill, would provide for a homestead household, a few animals, and a kitchen garden. This windmill is now one of several that water beef cattle on a ranch in New Mexico. It is 30 feet tall and its wheel has a diameter of 10 feet.

Plate 22

Norway in Montana
Park County, Montana
circa 1895

This writer remembers how the Old Country people preserved many of the traditions of "home." Having mid-morning coffee and *bullar* in our Swedish neighbors' farm houses was to a small boy nearly equivalent to a trip to Scandinavia—kitchens, parlors, language, religion, and all. And 20 miles over the hill, in the Scottish town of Naches, the same was true at my grandfather Donald MacIver's house. Here, in this Norwegian emigrant valley, these two homestead barns, made of both logs and milled lumber, are duplicates of their Old Country counterparts. The large one, in the background, measures 18 feet 6 inches by 40 feet in external plan, and is 20 feet tall.

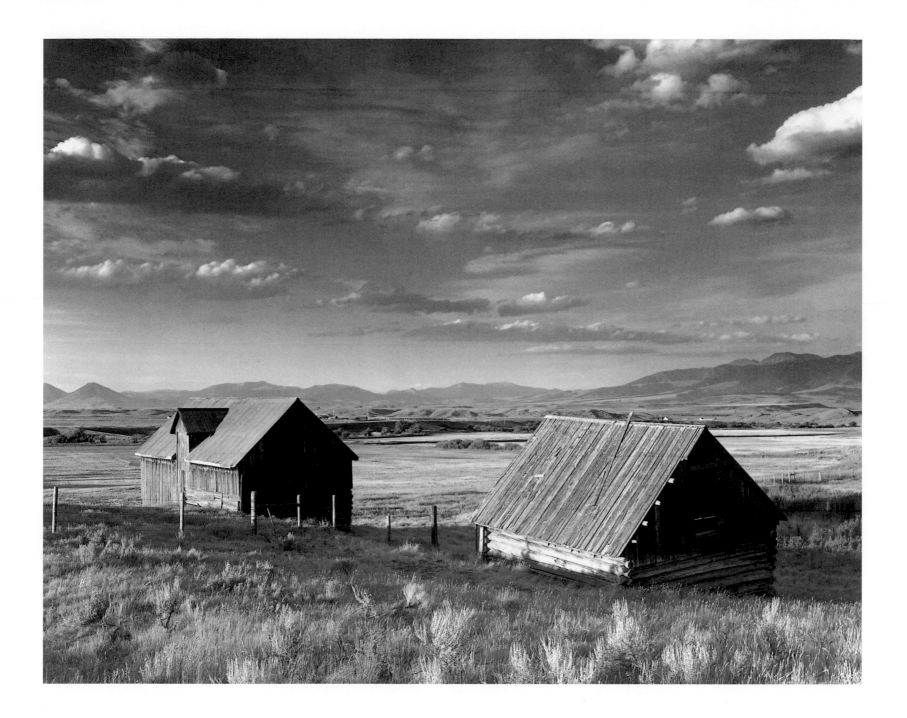

Plate 23

Barn Evolution
Divide County, North Dakota
circa 1900

In western North Dakota, early homestead gabled-plain barns were of a distinctive low, elongate form, and in the absence of stone or standing timber, both barns and other buildings were made of milled lumber. The typical early example in the middle foreground was built probably between 1890 and 1895; while it is only 20 feet tall, it contains a haymow and stalls below for horses or milk cows. With increasing affluence, the same owner built the big barn in about 1910. It is 30 feet tall, from ground to ridge, and in external plan measures 30 by 54 feet.

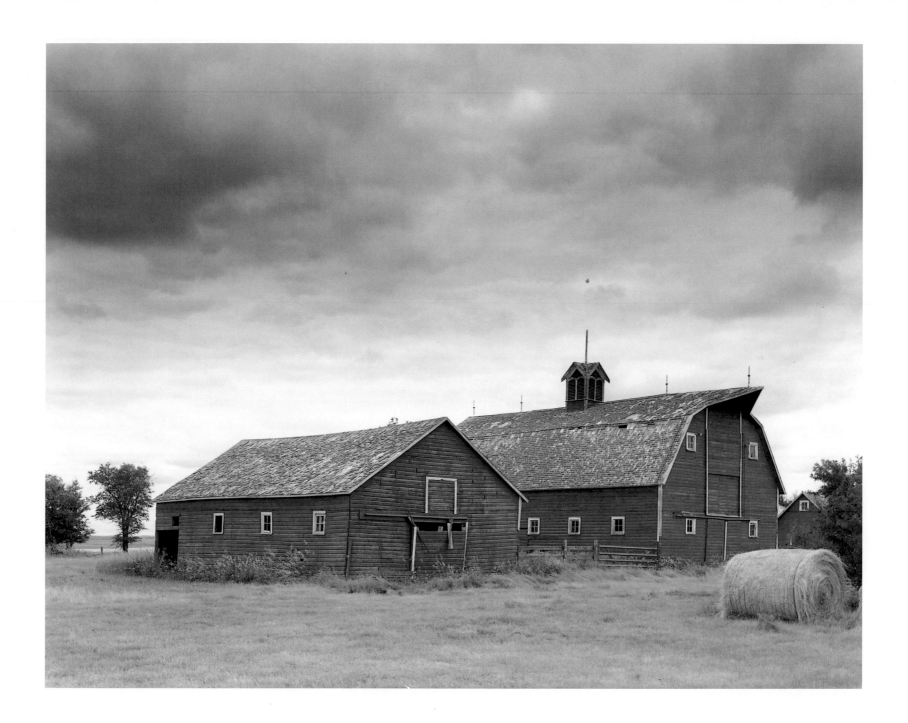

Plate 24

Homestead Farmyard
Crook County, Wyoming
date unknown

Neither the higher meadows and glades of the Black Hills nor their lower slopes and prairies offered successful homestead farming. Still, until they moved on or bought out their neighbors (to become cattle growers), thousands of homesteaders tried. The open, high-country meadows, cut by perennial creeks and bordered by pine forests, were especially attractive to the newcomers, and the typical Black Hills farmyard reflected the abundance of timber. Counting the main house, this homestead headquarters contains fourteen abandoned buildings, built either of logs or of boards from a neighbor's sawmill. A typical "first" barn is in the background. The log wagon is 11 feet long.

Plate 25

Northern Pacific Branch Line
Park County, Montana
circa 1910

Successful western homesteading (as ephemeral as that success turned out to be) required a web of rail lines. Wagon and auto roads were primitive dirt and gravel tracks, and without rails cash crops went begging for markets. These abandoned tracks, which ran 23 miles up-country from the Yellowstone River, were tied to the Northern Pacific Railroad, thus allowing its farm clientele to do business with Minneapolis, Seattle, and all points in between. Serving the Shields River Valley with its wheat and hay enterprises, the rails were put out of business by big trucks and a paved highway.

Plate 26

Railroad Station
Colfax County, New Mexico
1931

Most of the smaller homestead villages had their own rail lines that connected with the big roads: the Southern Pacific, Santa Fe, Great Northern, and others. And in every such village there was a depot that provided for both freight and passengers. This nice example was hauled 10 miles from the gone-broke homestead town of Farley to serve over the past several decades as a cattle rancher's repair shop. Although its rooms and back wall have been removed to accommodate ranch vehicles, its façade, gingerbread and all, is remarkably well preserved. Height from ground surface to eave above door is 13 feet.

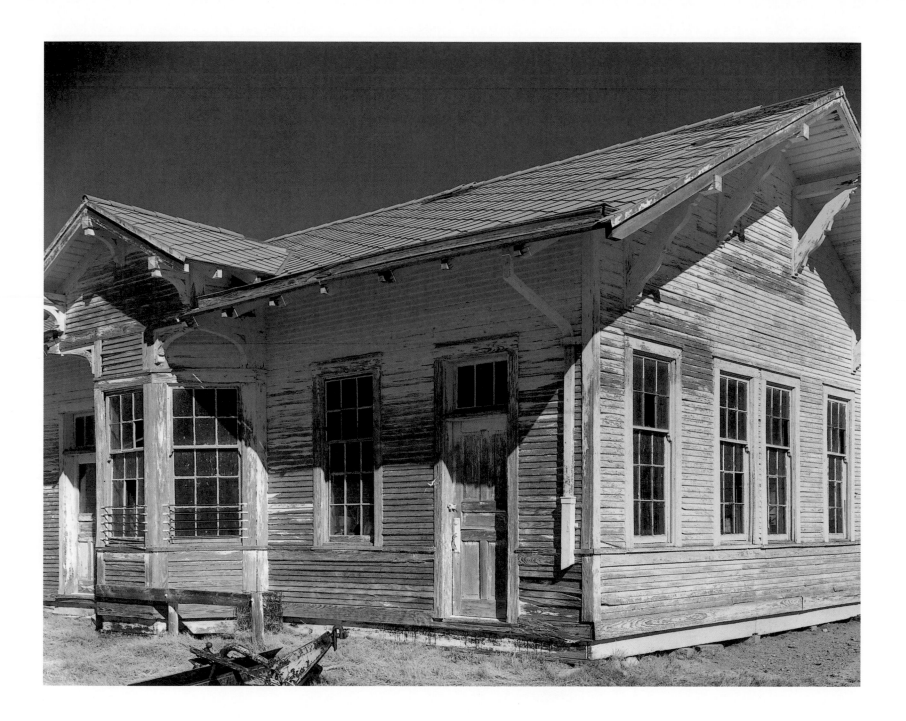

Plate 27

Disk Plow
Colfax County, New Mexico
date unknown

Plows of several types were essential to successful cash crop homesteading. Mounting discoidal steel blades on a heavy iron frame, this machine allowed a plowman with team or tractor to cultivate many times the acreage permitted by the ancient walking plow shown in Plate 7. Four horses pulled this International Harvester model of uncertain vintage, now lying abandoned in a bean field grown back to native grasses. Each of its eleven blades is 20 inches in diameter. Its width is 10 feet.

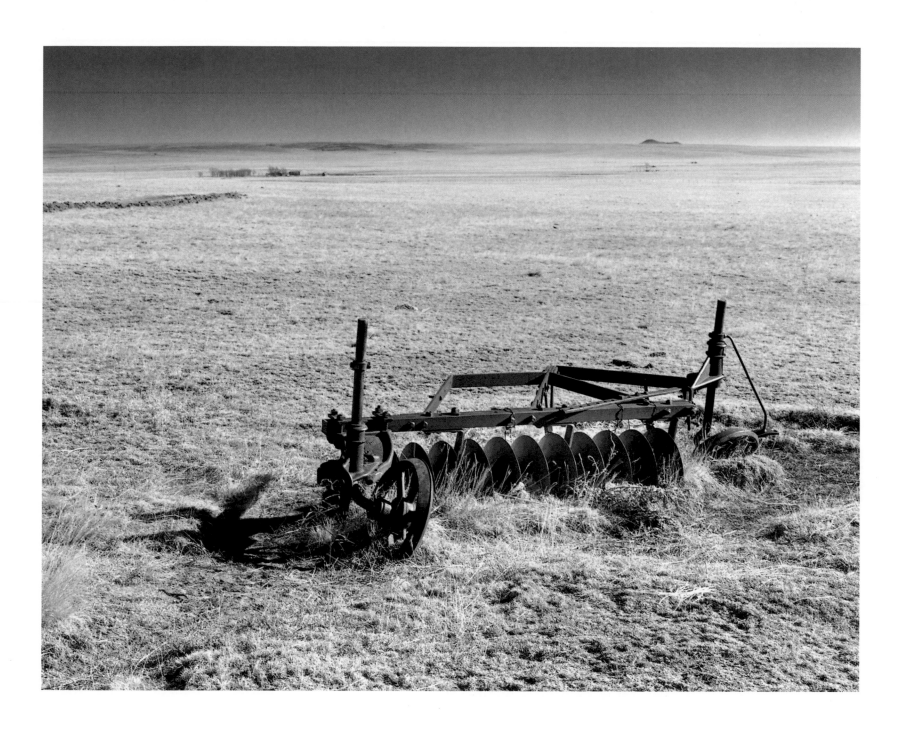

Plate 28

Spring Tooth Harrow
Yakima County, Washington
circa 1915

A harrow is an implement equipped with steel spikes or blades used before planting for breaking and pulverizing the big clods produced by plowing (Plate 27). The widely popular spring-tooth type, introduced to western homesteads in the late nineteenth century, came in several weights and sizes. This small example designed for a two-horse team contains four rows of teeth and was left behind by John and Maud Fontaine (see Chapter 1). Measured around its curve, each flexible tooth is 3 feet long.

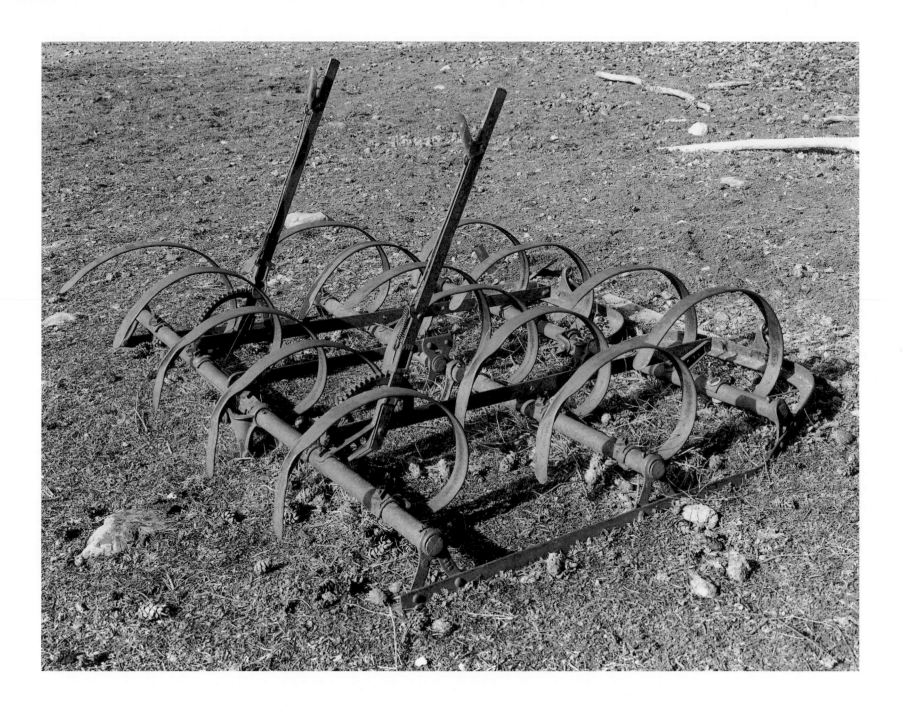

Plate 29

Drill

Las Animas County, Colorado

circa 1920

Successful planting of more than a few acres required a drill, a machine that both scatters and covers seed in ground prepared for planting beforehand. The grain box shown here measures 12 feet 6 inches from left to right and holds 720 pounds of grain. The seeds are deposited beside each of eleven steel blades which simultaneously cut furrows and cover them over. Pulled by a 30-horsepower tractor driven by an experienced farmer, this model can seed 50 or 60 acres in a twelve-hour day. It weighs 800 pounds.

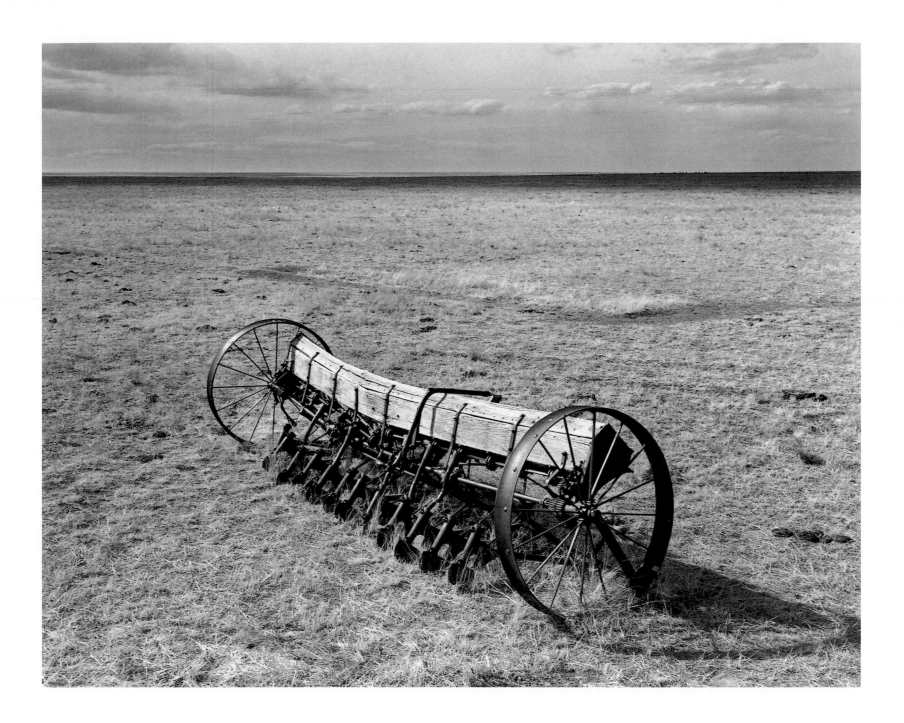

Plate 30

Combine
Park County, Montana
1922

This 1922 International Harvester combine is an early example of the farm imple-
ment that replaced the venerable threshing machine shown in Plate 31. (In turn, the
invention of the threshing machine, in the last half of the nineteenth century, was a
marvelous improvement over the age-old technique of cutting and threshing wheat
by hand.) Combines mow the standing ripe wheat, separate kernels from stalks, and
disgorge the resulting straw, all in a single operation. Several decades ago, the owners
of this wheat farm fenced off as a souvenir, this, their first combine. It is 11 feet tall.

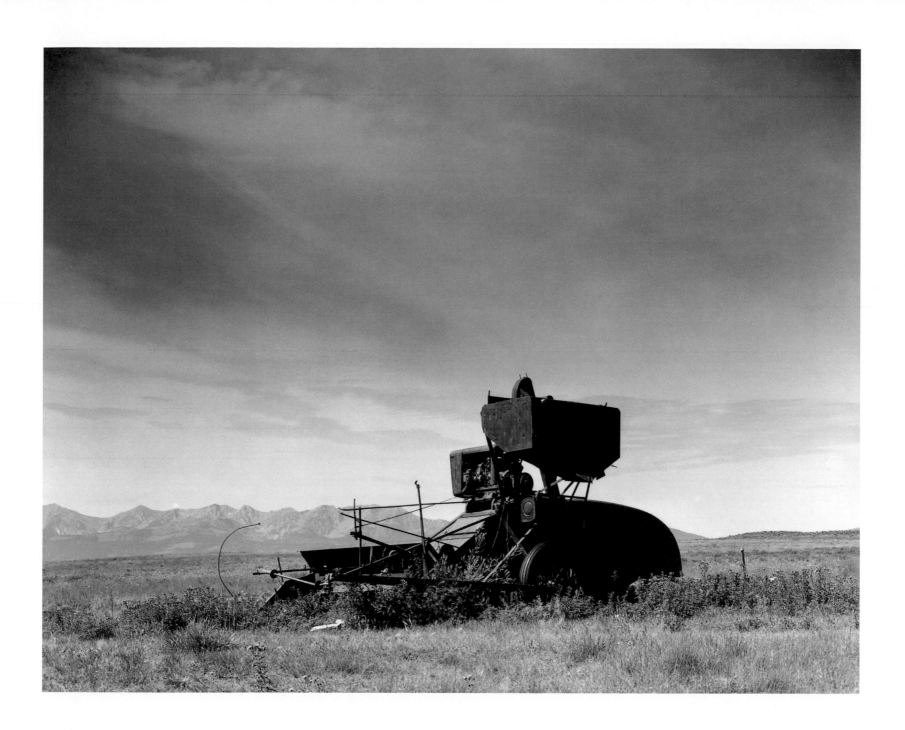

Plate 31

Threshing Machine
Divide County, North Dakota
date unknown

The nineteenth-century invention of the threshing machine saved an unbelievable number of hours in the age-old process of separating grain from chaff. Threshing machines were powered by auxiliary steam-driven or gasoline-driven vehicles. Shocks of wheat or other grain were fed to the conveyer at left front, which in turn fed them to an arrangement of revolving cylinders that separated the kernels and poured them into hand-held bags through the pipe "auger," shown folded in this picture. A machine like this one could thresh a thousand bushels a day, and in the mid-1930s sold for $1,400. Overall length is 31 feet.

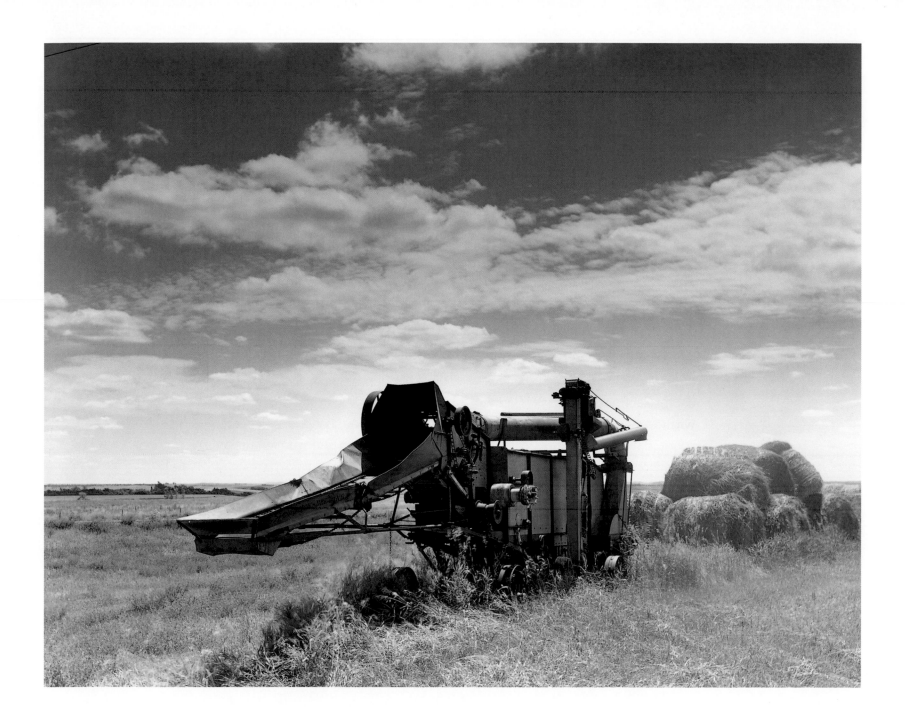

Plate 32

Plows, Harrows, and Disks
Chicago, Illinois
1908

This page from a 1908 Sears and Roebuck catalog describes the famous walking plow (see Plate 7) and other implements used in early western homesteading. With ordering instructions in English, German, and Swedish, the Sears catalog provided farmers with every necessary or desirable item imaginable, from cough medicine to mouse-proof pianos. It was the dream book of the working man and woman, mailed free to anyone who sent a postcard to Sears's Chicago headquarters. And "last year's" issue, with its 1,184 thin pages, served as "bathroom tissue" in every farm privy from Maine to Oregon.

YOU CANNOT AFFORD TO OVERLOOK THE
WONDER VALUES ON THIS PAGE

OUR WONDER VALUE DISC HARROWS.

$14⁵⁵

ALL STEEL FRAME AND WEIGHT BOXES.

We offer these high grade up to date Double Lever Disc Harrows at prices lower than have ever been attempted upon discs of even most inferior quality. There are no more durable or perfect working disc harrows on the market and at our prices they are value which no other house can duplicate.

No. 32K435 8-16-Inch Disc Harrow. Wt., 460 lbs. Price.....**$14.55**
No. 32K436 10-16-Inch Disc Harrow. Wt., 480 lbs. Price.....**$15.95**
No. 32K437 12-16-Inch Disc Harrow. Wt., 500 lbs. Price.....**$17.35**
No. 32K438 14-16-Inch Disc Harrow. Wt., 515 lbs. Price.....**$18.95**
No. 32K439 16-16-Inch Disc Harrow. Wt., 530 lbs. Price.....**$20.65**

OUR WONDER VALUE PONY GANG PLOWS

$12⁸⁷

These Walking Gang Plows are old time favorites. Perfectly adapted for all kinds of shallow plowing and especially desirable for orchard cultivation. Each plow bottom is 9 inches wide and the entire width of cut of the plow is 27 inches. Price is for the plow complete, as shown in the illustration. Plows with chilled or combination bottoms furnished with three extra chilled shares, but no extra shares are furnished with No. 32K432.

No. 32K430 Chilled Pony Gang Plow. Wt., 295 lbs. Price.....**$12.87**
No. 32K431 Combination Pony Gang Plow. Wt., 295 lbs. Price.....**$14.55**
No. 32K432 Steel Pony Gang Plow. Wt., 295 lbs. Price.....**$17.85**

OUR WONDER VALUE BRUSH AND GENERAL PURPOSE PLOWS.

$7³⁵

This is one of the most popular styles of plows on the market, as it serves the purpose of a brush plow and its shape also makes it possible to use it for tame sod or stubble plowing. Moldboard, landside and share are of solid steel. This is a strong, serviceable plow and one for which every farmer has need. Price is for the plow complete, as shown in the illustration.

No. 32K415 12-Inch Brush Plow. Wt., 85 lbs. Price.....**$7.35**
No. 32K416 14-Inch Brush Plow. Wt., 90 lbs. Price.....**$7.70**

OUR WONDER VALUE ROD BREAKING PLOWS.

$5⁷⁵

These are the highest grade and best built plows of their type. Have solid steel beam and are well braced throughout. Adjustable steel rods take the place of a moldboard. Share and fin cutter are of solid steel. Price is for plow complete, and one extra share.

No. 32K420 12-Inch Rod Breaking Plow. Wt., 63 lbs. Price.....**$5.75**
No. 32K421 14-Inch Rod Breaking Plow. Wt., 64 lbs. Price.....**$5.95**
No. 32K422 16-Inch Rod Breaking Plow. Wt., 67 lbs. Price.....**$6.15**

NOW IS THE TIME FOR YOU TO BUY.

We can save you big money on farm implements and machinery of all kinds. The articles shown on this page are selected from our regular stock and are but examples of the astonishing value represented by every farm implement and machine shown in this catalogue.

WHILE OUR PRICES ARE ABOUT ONE-HALF WHAT OTHERS ASK, no one can furnish you with a superior quality of goods. If extra fine quality, absolutely perfect and up to date goods at a saving of nearly one-half to you will bring your order, we are entitled to all of your business on farm machinery. Our guarantee to please you in every way or return your money (an offer which is made by no other house in the world) is so very liberal that our farm machinery for our own protection must be right.

WE GUARANTEE TO SATISFY YOU or you get every cent of your money back and freight charges both ways, and we repeat, if you are not satisfied in every way with any piece of farm machinery purchased from us, return it at our expense and we will refund your money along with any freight charges you may have paid out.

You will always find our quality the highest and our prices the lowest.

OUR WONDER VALUE STEEL WALKING PLOWS

OTHERS ASK $12.00 TO $15.00 FOR NO BETTER.

$7⁷³

SHARE, MOLDBOARD AND LANDSIDE MADE OF SOFT CENTER STEEL.

These plows are equal in every way to any plows you can possibly buy elsewhere, and we guarantee them to give you perfect satisfaction. We furnish them in either stubble or turf and stubble shape. Be sure to specify which you want. These are high grade plows in every sense of the word.

STRONG AND RIGID, SMOOTH RUNNING, PERFECT SCOURING.

No. 32K401 12-Inch Walking Plow. Wt., 98 lbs. Price.....**$7.73**
No. 32K402 14-Inch Walking Plow. Wt., 103 lbs. Price.....**8.44**
No. 32K403 16-Inch Walking Plow. Wt., 107 lbs. Price.....**9.42**

OUR WONDER VALUE STEEL SULKY PLOWS

$24⁷⁵

OUR PRICE MEANS A SAVING TO YOU OF FROM $10.00 TO $15.00.

HIGH LIFT

SOFT CENTER STEEL MOLDBOARD, LANDSIDE AND SHARE.

BEAM HITCH

Here is positively the greatest Sulky Plow offer ever made. No one else has ever been able to offer such high grade, first class sulky plows for prices so low as we here quote. We furnish these plows in either stubble or turf and stubble bottom. When ordering state which you want. Price is for the plow complete with pole, neckyoke, three-horse evener, weed hook and rolling coulter.

No. 32K405 14-Inch Sulky Plow. Wt., 455 lbs. Price.....**$24.75**
No. 32K406 16-Inch Sulky Plow. Wt., 460 lbs. Price.....**25.65**

OUR WONDER VALUE STEEL GANG PLOWS

$39⁹⁵

EQUAL IN EVERY WAY TO GANG PLOWS WHICH OTHERS SELL FOR FROM $50.00 TO $60.00

HIGH LIFT

SOFT CENTER STEEL MOLDBOARD, LANDSIDE AND SHARE

BEAM HITCH

PRICE INCLUDES TWO ROLLING COULTERS

These are strictly up to date High Lift Gang Plows and superior in many ways to almost any gang plow which any other concern can offer you. Our price represents positively the greatest value ever offered in a gang plow. We furnish these plows in either stubble or turf and stubble shape. When ordering specify which you want. Furnished complete with pole, neckyoke, weed hooks, two rolling coulters and four-horse evener.

No. 32K410 12-Inch Gang Plow. Wt., 675 lbs. Price.....**$39.95**
No. 32K411 14-Inch Gang Plow. Wt., 680 lbs. Price.....**40.85**

OUR WONDER VALUE PRAIRIE BREAKING PLOWS.

$7³⁷

This is the most popular style of Prairie Breaking Plow on the market and is too well known to need further description. Price is for the plow complete, as shown in the illustration and with one extra share. We will furnish plow with gauge wheel and rolling coulter for $1.85 extra.

No. 32K425 12-Inch Prairie Breaking Plow. Wt., 135 lbs. Price.....**$7.37**
No. 32K426 14-Inch Prairie Breaking Plow. Wt., 137 lbs. Price.....**7.65**
No. 32K427 16-Inch Prairie Breaking Plow. Wt., 140 lbs. Price.....**7.85**

OUR WONDER VALUE CULTIVATORS.

$17⁶⁵

This is one of the most desirable combined Riding and Walking Cultivators on the market. All steel, excepting the pole and hitch. Wheels have wide tires and dustproof, oiltight long distance bearings, and can be adjusted from 4 to 8 feet wide.

No. 32K450 4-Shovel Break Pin Cultivator. Wt., 410 lbs. Price.....**$17.65**
No. 32K451 6-Shovel Break Pin Cultivator. Wt., 425 lbs. Price.....**$18.15**
No. 32K452 5-Shovel Break Pin Cultivator. Wt., 435 lbs. Price.....**$18.70**
No. 32K453 4-Shovel Spring Trip Cultivator. Wt., 435 lbs. Price.....**$19.25**
No. 32K454 6-Shovel Spring Trip Cultivator. Wt., 465 lbs. Price.....**$20.65**

OUR WONDER VALUE ANGLE BAR HARROWS

$3⁴³

This is one of the most satisfactory wood frame harrows made. Will harrow lengthwise of sod and not track. Frame of seasoned oak, strongly riveted at each tooth and firmly braced. Teeth are ½ inch square. Price includes draw bar.

No. 32K440 48-Tooth Angle Bar Harrow. Wt., 125 lbs. Price.....**$3.43**
No. 32K441 60-Tooth Angle Bar Harrow. Wt., 160 lbs. Price.....**$4.29**
No. 32K442 72-Tooth Angle Bar Harrow. Wt., 190 lbs. Price.....**$5.15**
No. 32K443 90-Tooth Angle Bar Harrow. Wt., 210 lbs. Price.....**$6.43**

OUR WONDER VALUE SPRING TOOTH HARROWS

$5⁸⁵

These harrows are too well known to need description. Frames are of seasoned oak and fitted with stump guards around the sides and front. Teeth are standard size, made of high quality tempered spring steel and are firmly secured. Price includes draw bar.

No. 32K445 16-Tooth Harrow. Wt., 160 lbs. Price.....**$5.85**
No. 32K446 18-Tooth Harrow. Wt., 170 lbs. Price.....**$6.65**
No. 32K447 20-Tooth Harrow. Wt., 180 lbs. Price.....**$7.45**

OUR WONDER VALUE COMBINED FEED CUTTER AND SHREDDER.

$18⁹⁵

You cannot buy the equal of this machine elsewhere for less than $30.00. It cuts the fodder into short lengths and at the same time shreds each piece into small parts. Can be run by either hand or power. Requires from one to two-horse power to run it. Has 11-inch cylinder head, with thirty-eight knives. Price includes crank and pulley.

No. 32K460 Feed Cutter and Shredder. Wt., 325 lbs. Price.....**$18.95**

OUR WONDER VALUE SWEEP HORSE POWERS.

These powers are of standard design, strongly constructed, and will give splendid service and continued satisfaction. Shafts are steel and boxes babbitted; have high and low speed shafts. Illustration shows a two and four-horse power. Six-horse powers have four sweeps. Price includes about 20 feet of tumbling rod, three couplings, rod block, platform, and spring hitch for each sweep. Lead poles are furnished with two and four-horse powers.

No. 32K465 Two-Horse Power. Wt., 725 lbs. Price.....**$20.75**
No. 32K466 Four-Horse Power. Wt., 1,015 lbs. Price.....**$28.15**
No. 32K467 Six-Horse Power. Wt., 1,050 lbs. Price.....**30.75**

$20⁷⁵

Plate 33

Tractor
Las Animas County, Colorado
1927

It took a four-horse team to pull the sort of disk plow shown in Plate 27, and given the care and feeding required by horses, most homesteaders opted for tractors as soon as technology and pocketbook permitted. This McCormick-Deering "Farmall," made by International Harvester, is a 1927 model, and it had considerably more power than a four-horse team. Among many of the same or similar-type tractors used by Colorado prairie homesteaders, it sold for $1,200. Its total length is 11 feet, 6 inches.

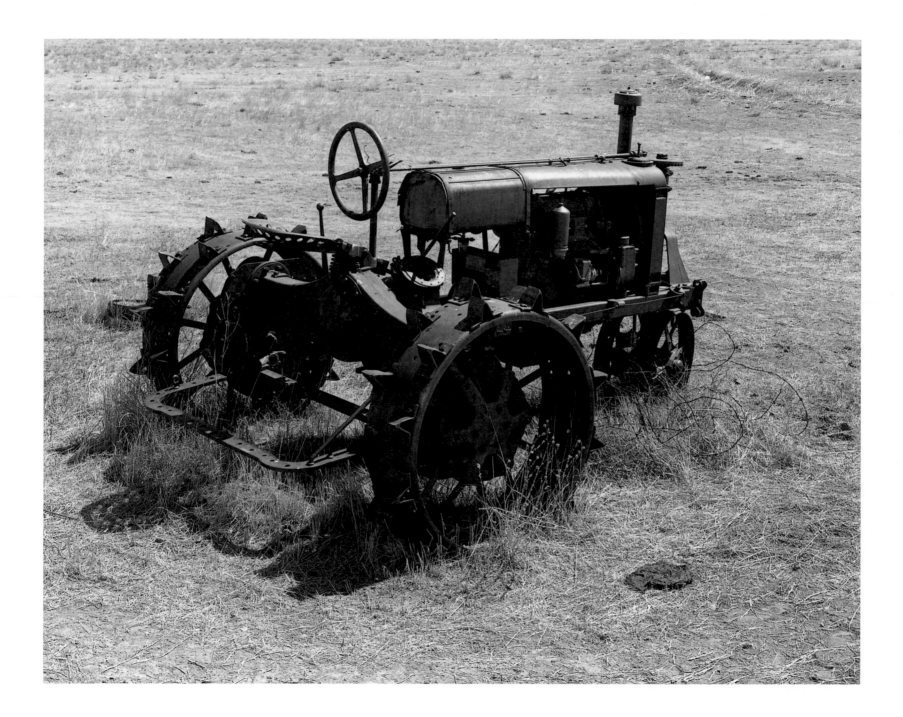

Plate 34

Lambing Shed
Park County, Montana
1940

Many thousands of homesteaders found to their sorrow that most of the big sage country would not support dry farming. But these same sagebrush–bunch grass prairies proved ideal for sheep grazing, provided the homesteader could hang on, buy his neighbors' land, and acquire public grazing permits. The lambing shed was a necessary part of all such sheep-growing enterprises. Each April, sheds like this grand, abandoned example whose length is 180 feet, served as maternity wards for a thousand ewes. The annex at the right was for shearing. Today, the homesteader's descendants have gone over to wheat and cattle, as witnessed by the fields in the background and corrals at lower left.

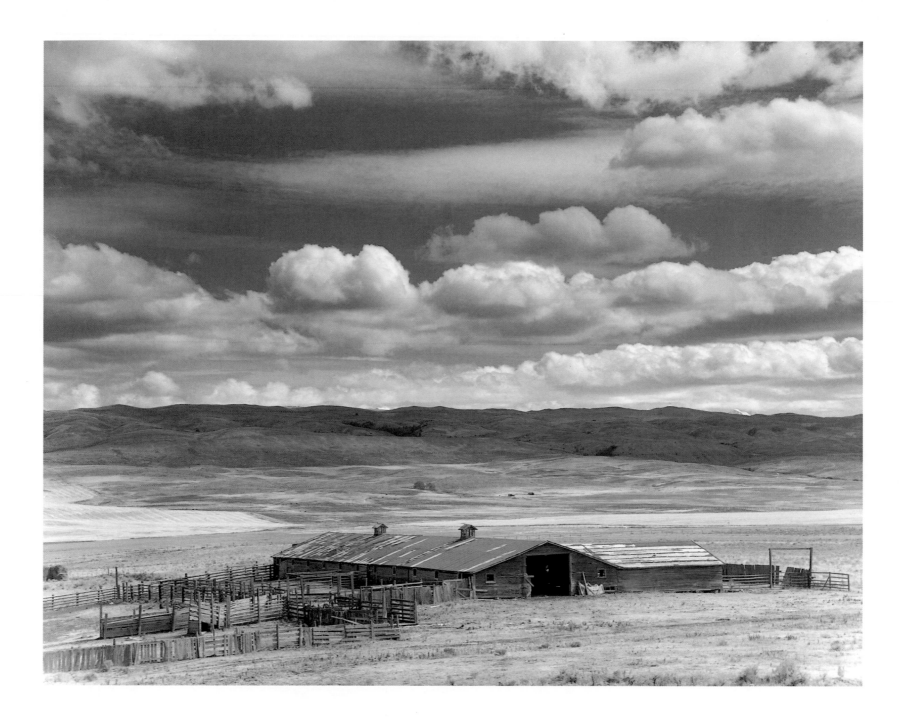

Plate 35

Wheat

Meagher County, Montana

1996

In theory, dry-land wheat was among the most promising of homestead crops, but to make a living at it you had to have many times the acreage allotted to one or even several homesteads. Here, in the sagebrush country of central Montana, some home-steaders managed to hang on by buying out dozens of their neighbors. Growing dry-land wheat remains to this day a sporting proposition, however. After harvesting, a field must lie fallow for at least a year. Given that only half of one's wheat holdings are producing at any one time, to stay even, a dry-land wheat farmer needs some 5,000 acres of wheat land.

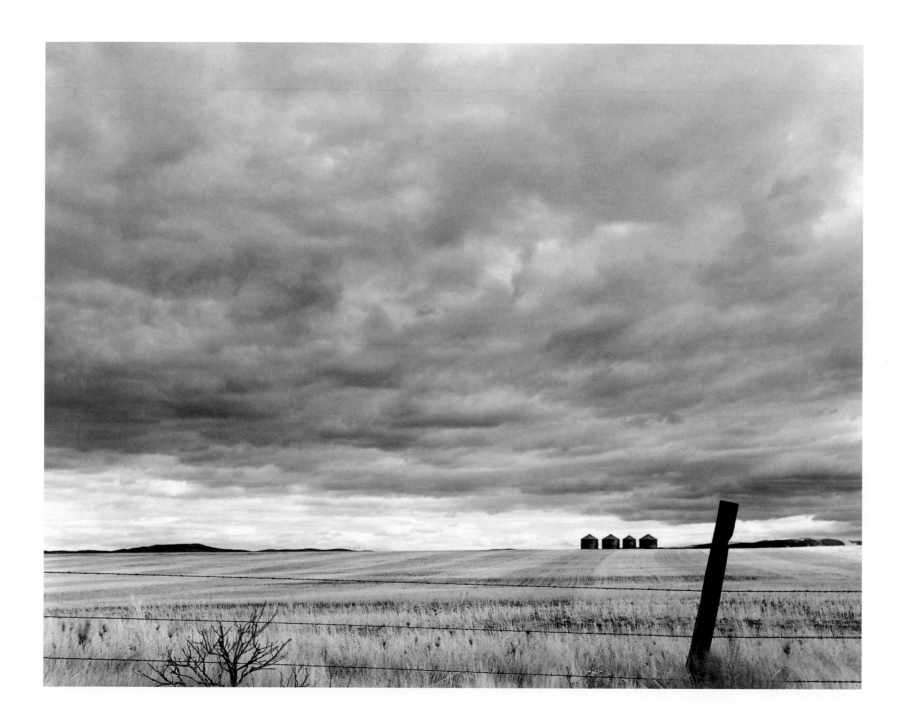

Plate 36

Prosperity
Meagher County, Montana
circa 1925

This 1920s automobile reflects the increasing prosperity enjoyed by some home-steaders as they enlarged their holdings and acquired federal permits with which to graze livestock on U.S. lands. Still, with the coming of the Great Depression this farmer-turned-rancher sold out cheap. Typical of most such abandoned enterprises, the property has long since become part of a cattle ranch and is used mainly for growing hay in the bottom lands of a sagebrush country river. Outside diameters of the car's headlights are 10 inches.

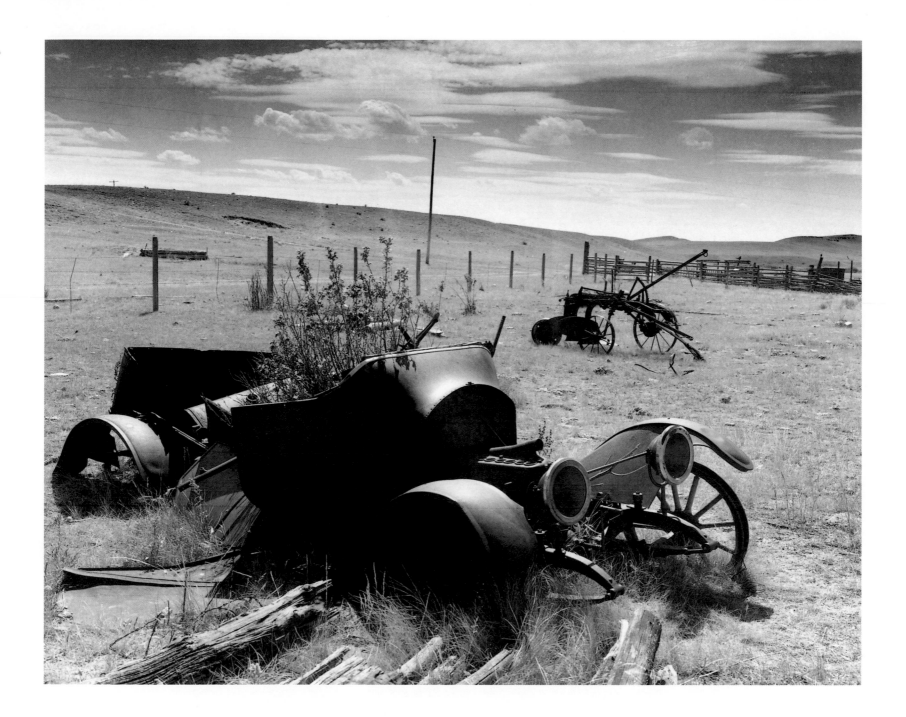

Plate 37

A House Built on Pinto Beans
Union County, New Mexico
circa 1912

Success allowed for multi-room family dwellings designed by either professional or amateur architects and built of store-bought materials. This fine example has five ground rooms, and probably its spacious attic contained one or two others, as suggested by its height and front dormer. Of nicely finished milled lumber, the house sits on a tall foundation of poured concrete. Its walls are of wood rather than stone or adobe, and it has the typical hipped roof of western homestead houses of the southern prairies. External horizontal dimensions are 24 by 39 feet, height from ground to ridge is 18 feet, and length of central ridge is 14 feet.

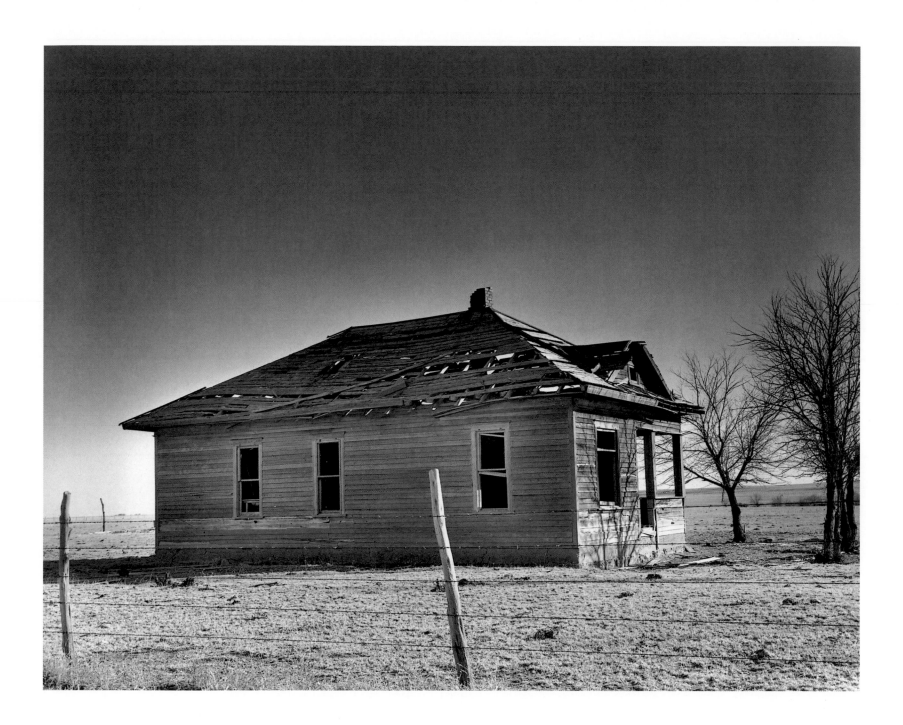

Plate 38

Making Good
Stillwater County, Montana
circa 1910

Fancy but excellent, this ten-room house reflects both homestead success and the eye of an accomplished architect, probably, but not necessarily, a trained professional. In addition to its large upstairs bedrooms and its well-designed kitchen and pantry, it contains a big, expansive parlor, large enough for formal dances. But best of all are its two-story bay windows that overlook the Yellowstone River. In fact, the only thing lacking in this grand house is an indoor toilet. It is 25 feet tall from ground to ridge, and in external plan measures 22 by 47 feet.

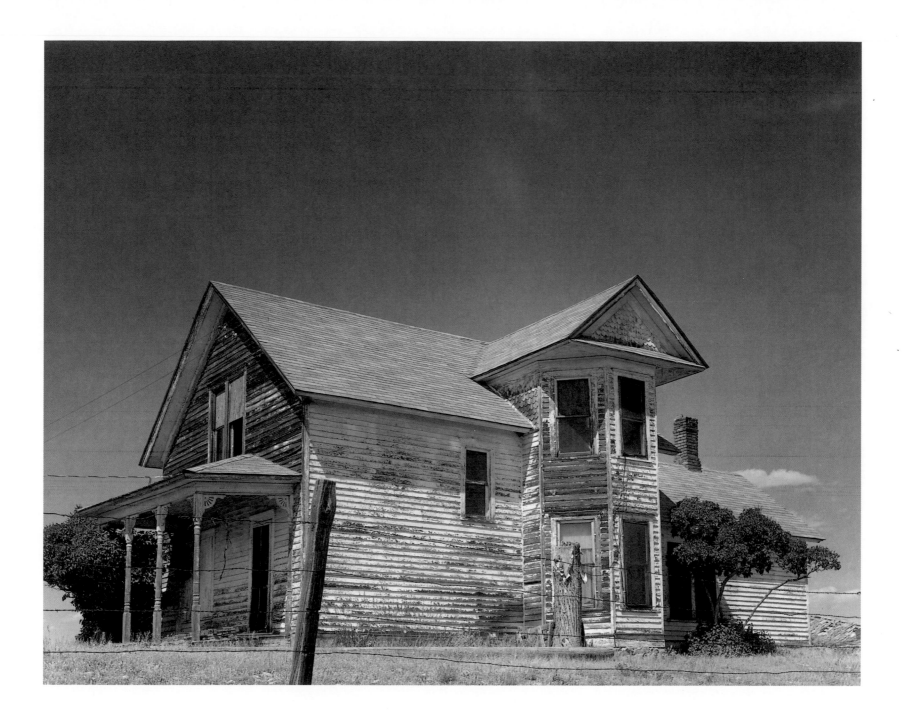

Plate 39

Prairie Mansion
Quay County, New Mexico
circa 1910

Not all of the newcomers started from scratch. The house shown here belonged to a lady from "back east." Before she went broke, she had cash to spare, as evidenced by this twelve-room mansion of her own design. An educated woman of imaginative mind, her idea was to provide a place of culture and awareness for her less-enlightened neighbors. The second-story tower facing the camera was built especially for seances. The tower peak stands 22 feet above ground surface.

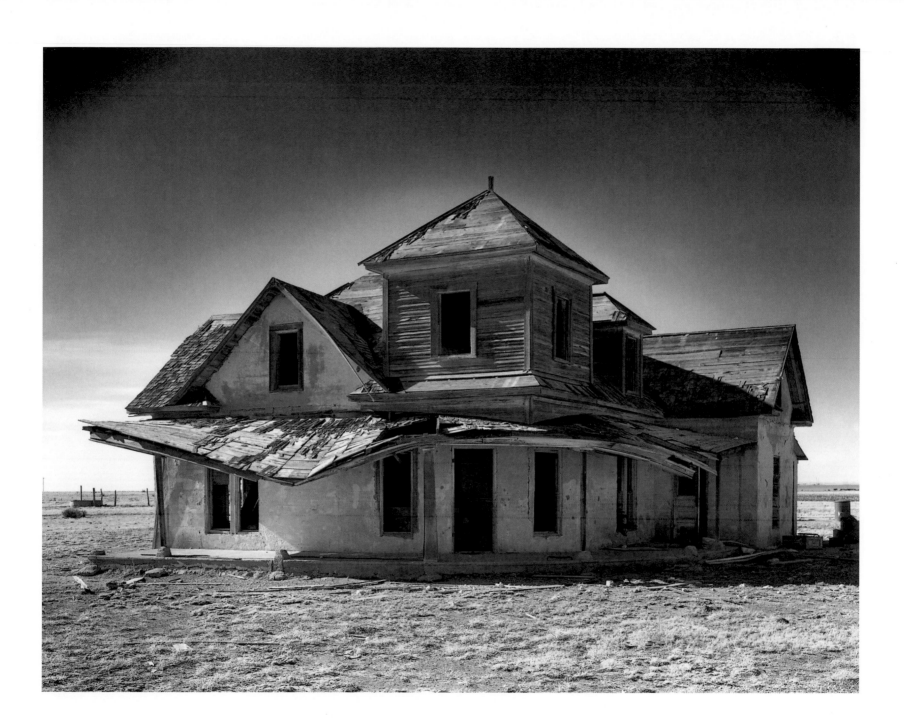

Plate 40

Sears and Roebuck House
Chicago, Illinois
circa 1920

Sears and Roebuck prefabricated houses became popular in the homestead West dur-ing the first two decades of the twentieth century. Special Sears catalogs of about 150 pages described some sixty-one different styles which, delivered in their constituent parts to the nearest rail depot, sold for between $900 and $5,000. The more pricey houses were imposing two-story structures of ten rooms or more. They were built most often in homestead towns, and were usually owned by well-heeled doctors, lawyers, and businessmen. The model shown here is more typical of those ordered by successful farmers (see Plate 41).

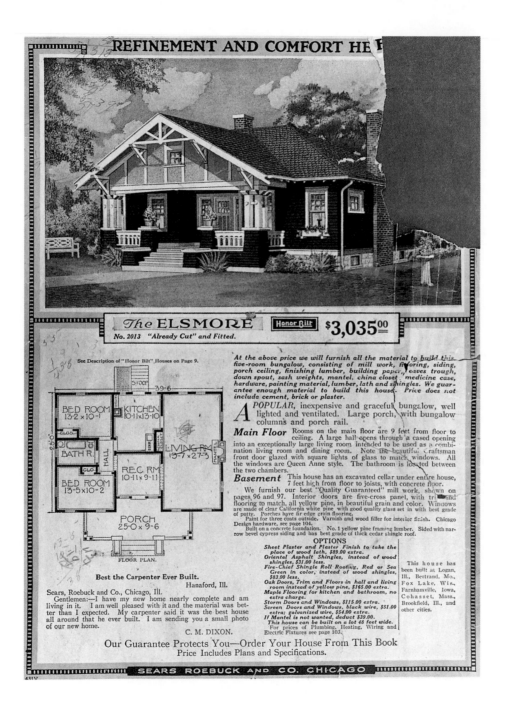

The ELSMORE — Honor Bilt — $3,035.00
No. 2013 "Already Cut" and Fitted.

See Description of "Honor Bilt" Houses on Page 9.

FLOOR PLAN.

BED ROOM 13-2 x 10-1
KITCHEN 10-11 x 13-10
BATH R.
HALL
LIVING RM 13-7 x 27-3
REC RM 10-11 x 9-11
BED ROOM 13-5 x 10-2
PORCH 25-0 x 9-6
39-6

At the above price we will furnish all the material to build this five-room bungalow, consisting of mill work, flooring, siding, porch ceiling, finishing lumber, building paper, eaves trough, down spout, sash weights, mantel, china closet, medicine case, hardware, painting material, lumber, lath and shingles. We guarantee enough material to build this house. Price does not include cement, brick or plaster.

A POPULAR, inexpensive and graceful bungalow, well lighted and ventilated. Large porch, with bungalow columns and porch rail.

Main Floor Rooms on the main floor are 9 feet from floor to ceiling. A large hall opens through a cased opening into an exceptionally large living room intended to be used as a combination living room and dining room. Note the beautiful Craftsman front door glazed with square lights of glass to match windows. All the windows are Queen Anne style. The bathroom is located between the two chambers.

Basement This house has an excavated cellar under entire house, 7 feet high from floor to joists, with concrete floor.

We furnish our best "Quality Guaranteed" mill work, shown on pages 96 and 97. Interior doors are five-cross panel, with trim and flooring to match, all yellow pine, in beautiful grain and color. Windows are made of clear California white pine with good quality glass set in with best grade of putty. Porches have fir edge grain flooring.

Paint for three coats outside. Varnish and wood filler for interior finish. Chicago Design hardware, see page 104.

Built on a concrete foundation. No. 1 yellow pine framing lumber. Sided with narrow bevel cypress siding and has best grade of thick cedar shingle roof.

OPTIONS
Sheet Plaster and Plaster Finish to take the place of wood lath, $89.00 extra.
Oriental Asphalt Shingles, instead of wood shingles, $31.00 less.
Fire-Chief Shingle Roll Roofing, Red or Sea Green in color, instead of wood shingles, $83.00 less.
Oak Doors, Trim and Floors in hall and living room instead of yellow pine, $165.00 extra.
Maple Flooring for kitchen and bathroom, no extra charge.
Storm Doors and Windows, $115.00 extra.
Screen Doors and Windows, black wire, $51.00 extra; galvanised wire, $54.00 extra.
If Mantel is not wanted, deduct $39.00.
This house can be built on a lot 48 feet wide.
For prices of Plumbing, Heating, Wiring and Electric Fixtures see page 103.

This house has been built at Logan, Ill., Bertrand, Mo., Fox Lake, Wis., Farnhamville, Iowa, Cohasset, Mass., Brookfield, Ill., and other cities.

Best the Carpenter Ever Built.

Hanaford, Ill.

Sears, Roebuck and Co., Chicago, Ill.

Gentlemen:—I have my new home nearly complete and am living in it. I am well pleased with it and the material was better than I expected. My carpenter said it was the best house all around that he ever built. I am sending you a small photo of our new home.

C. M. DIXON.

Our Guarantee Protects You—Order Your House From This Book
Price Includes Plans and Specifications.

Plate 41

The Sears Prefab at Home
Crook County, Wyoming
circa 1920

By horse-drawn wagon, or even motor truck, homestead farms lay commonly a day or better from the nearest rail depot. Over a span of more than a week, this Sears and Roebuck prefab was hauled piece by piece 40 miles to the farm, where it replaced a log cabin. Occupied today by a bachelor in his seventies (a grandson of the original homesteader), during the past eight decades the house has changed its face. Among other modifications, its front porch has been taken in. Still, it is the same model precisely as that shown in Plate 40.

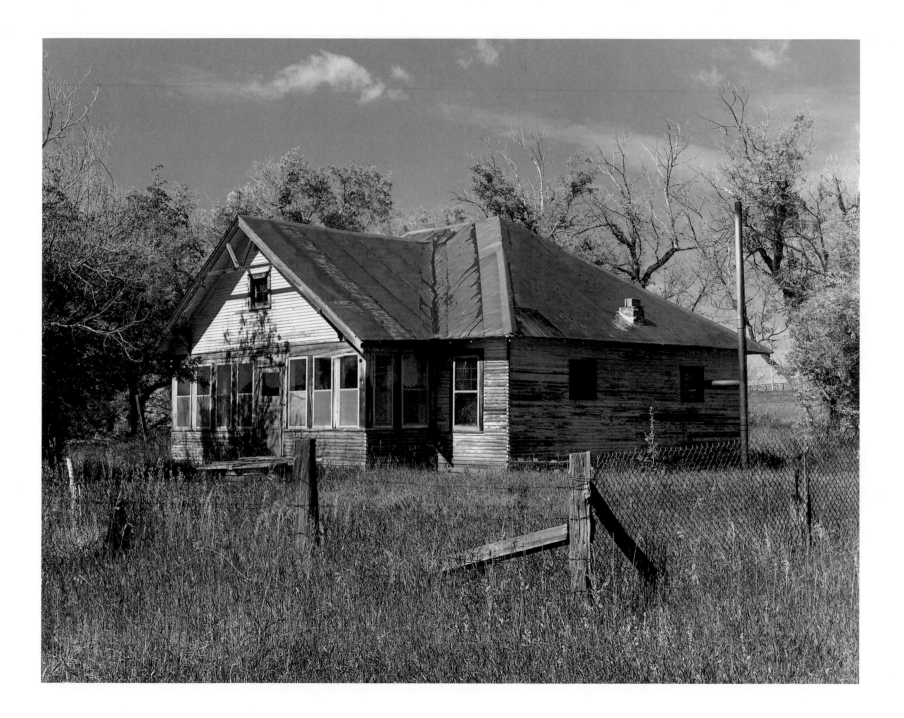

Plate 42

Privy

Gallatin County, Montana

circa 1915

For many an arriving western homesteader an outhouse was hardly a first priority. Putting up shelters for man and beast took precedence. Meantime, there was the bucket or pot under the bed, and of course the great out-of-doors. But in addition to their (sometimes doubtful) sanitary advantages, privies were in demand by homestead society for other reasons. Without a proper privy, one simply did not belong. With the glacier-carved Bridger Range as a scenic backdrop, this example on the bank of Flathead Creek is a typical "two-holer," by far the most popular of western designs. From ground to ridge top it is 11 feet tall.

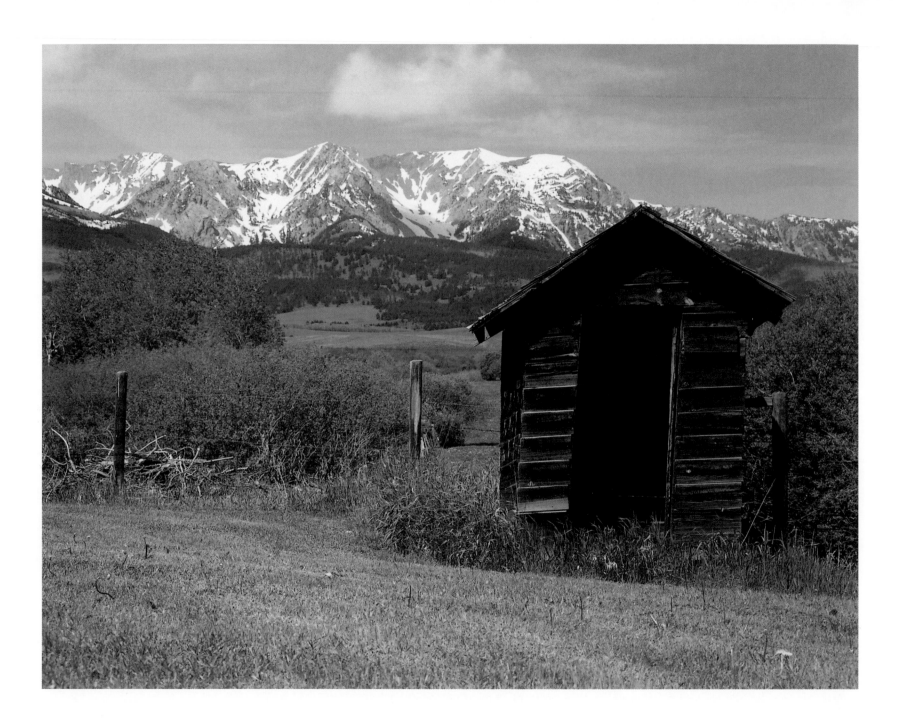

Plate 43

Basin and Pitcher
Morrow County, Oregon
circa 1910

Until the 1930s indoor plumbing was a luxury unknown to all but a few western homesteaders; the privy was out back. For more immediate convenience a chamber pot (politely called simply "chamber") was hidden beneath the bed, and for washing up in the morning and evening the well-appointed bedroom contained a basin and pitcher, the latter replenished daily from well, spring, or creek. In 1910 these typical porcelain examples sold as a set for two dollars. The pitcher holds 6 quarts.

Plate 44

Indoor Plumbing
Yakima County, Washington
1928

When subterranean water ran reasonably close to the ground surface, wells soon replaced cisterns or water buckets replenished daily from nearby streams. The most common household wells in the late nineteenth and early twentieth centuries were dug by hand or by itinerant well drillers with horse-powered machines. They delivered water by means of a vertical pipe, whose top was fitted with a hand pump. Early on, the hand pump was an outdoor fixture, but over the years it slowly made its way into the kitchen. The enterprising owner of this one-room cabin dug the well first, then built her house around it. The pump is 19 inches tall.

Plate 45

Kitchen Range
Morrow County, Oregon
date unknown

Every established farmhouse had its kitchen range, a stove that burned wood or coal and that often provided the dwelling with its only source of heat. (In the bitter winters of the northern prairies, home life centered on the kitchen and its range.) Like others of its kind, this early example accommodates pots and pans for boiling and frying on its flat top; its roasting oven will hold a haunch of venison; and a "warming closet" incorporated into the stove pipe at the top keeps the food hot until served. The "Majestic" shown here is 56 inches tall and in the early 1900s sold for less than $20.

Plate 46

A Saltbox Barn
Colfax County, New Mexico
circa 1910

Some arriving homesteaders brought their architecture with them. In churches and barns, most particularly, the tastes and styles of such far-flung homelands as Norway, Germany, the Ukraine, and New England became regional hallmarks. In this writer's opinion the most charming of western homestead barn types was the saltbox. Most common in parts of Montana and New Mexico, it was derived from the famous saltbox dwelling of colonial New England. In external plan this classic example measures 29 feet 6 inches by 32 feet. It is 24 feet tall.

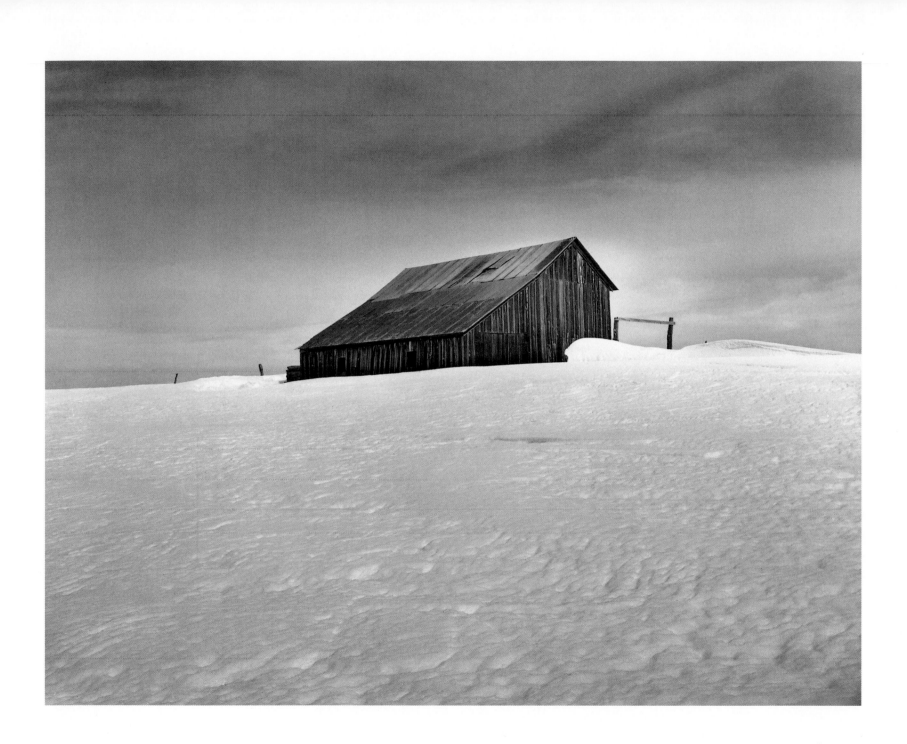

Plate 47

Bethany Church
Divide County, North Dakota
circa 1910

Divide County's rolling, glaciated landscape remains among the more scenically up-lifting homestead regions in all of the West. That uplifting spirit is symbolized here by the towering spire of Bethany Church, whose top soars 70 feet above the prairie. Some miles north, near the Saskatchewan border, the descendents of Ukrainian homesteaders worship in an Eastern church, Byzantine domes and all, but most of rural Divide County remains quite solidly Norwegian Lutheran. For the reasons noted in Chapter 3, the old homesteads are incorporated now into big wheat farms, and Bethany has gone without a pastor or congregation for decades. Both this church and its graves, however, are still tended faithfully by the great-grandchild of one of the original homesteaders.

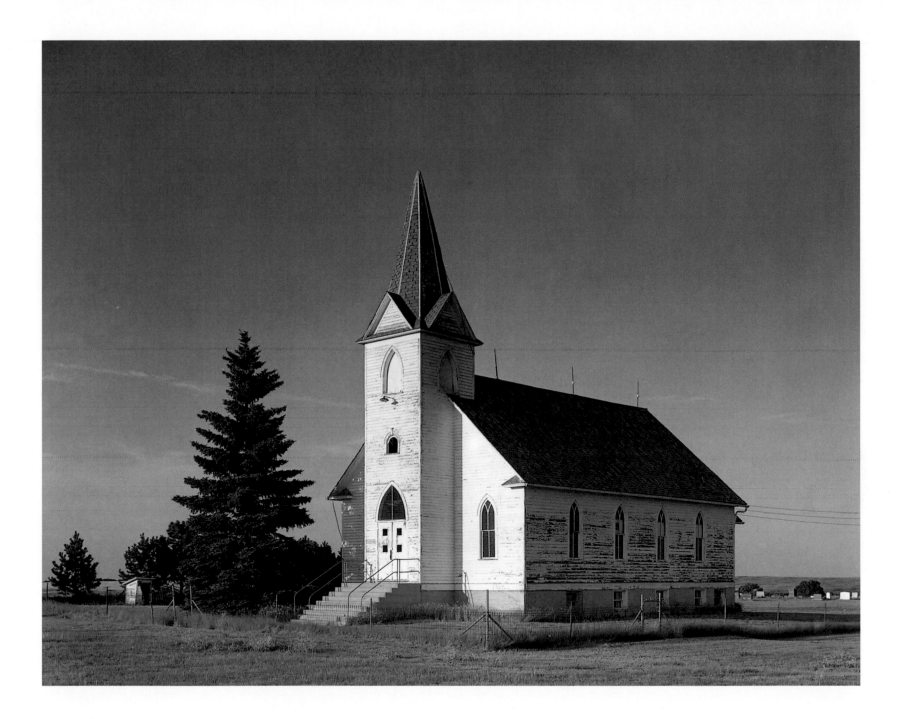

Plate 48

Dairy Barn
Thurston County, Washington
1898

This barn, of the gabled-plain style, was built for sheltering cows and storing hay, but here in western Washington, the animals were dairy cows, not beef cattle. Typical of the big coastal dairy barns, the posts, beams, and rafters of this barn are made from logs and poles that were cut in the surrounding deep forest as it was cleared for pasture. They were later stripped of their bark with hand tools. The photograph shows part of the great loft. Measuring 43 feet wide, 152 feet long, and 21 feet tall from loft floor to ridge, the barn held 250 tons of loose hay.

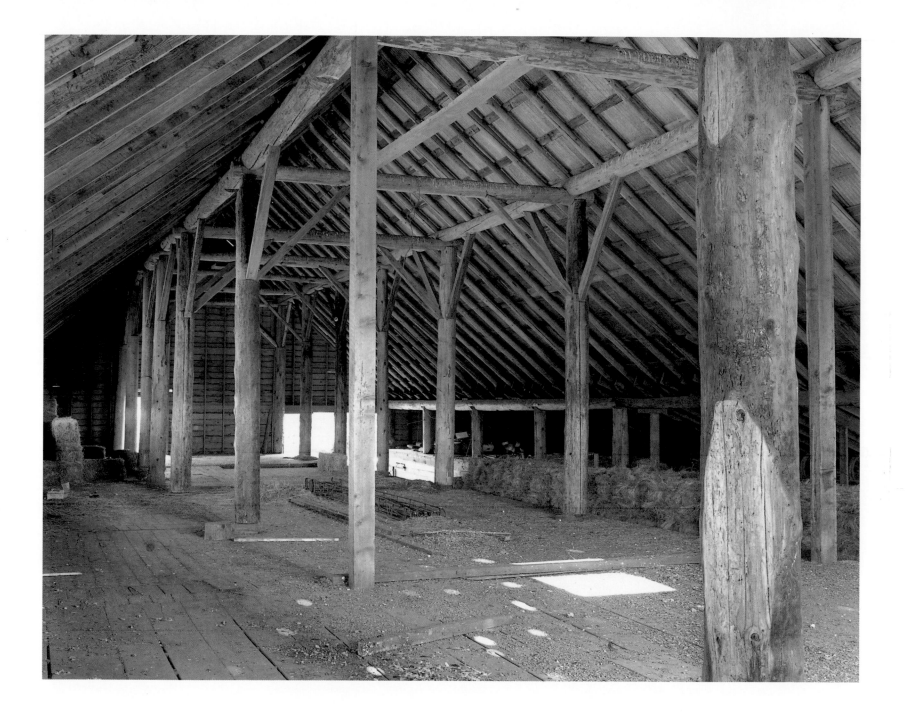

Plate 49

Log Barn
Park County, Montana
circa 1895

Measuring 24 vertical feet from ground to ridge and 21 feet 6 inches by 50 feet in external plan, this barn of the gabled-plain style is an unusually large example of homestead log architecture. Cut in a nearby ponderosa pine forest and skidded home over winter snow behind a team of horses, the logs were laid up to wall heights of 12 feet. Because they average 9 feet in length and 8 inches in diameter, getting them up required skill, ingenuity, and block and tackle. Chinking is of split and whittled pine splints driven horizontally between the logs.

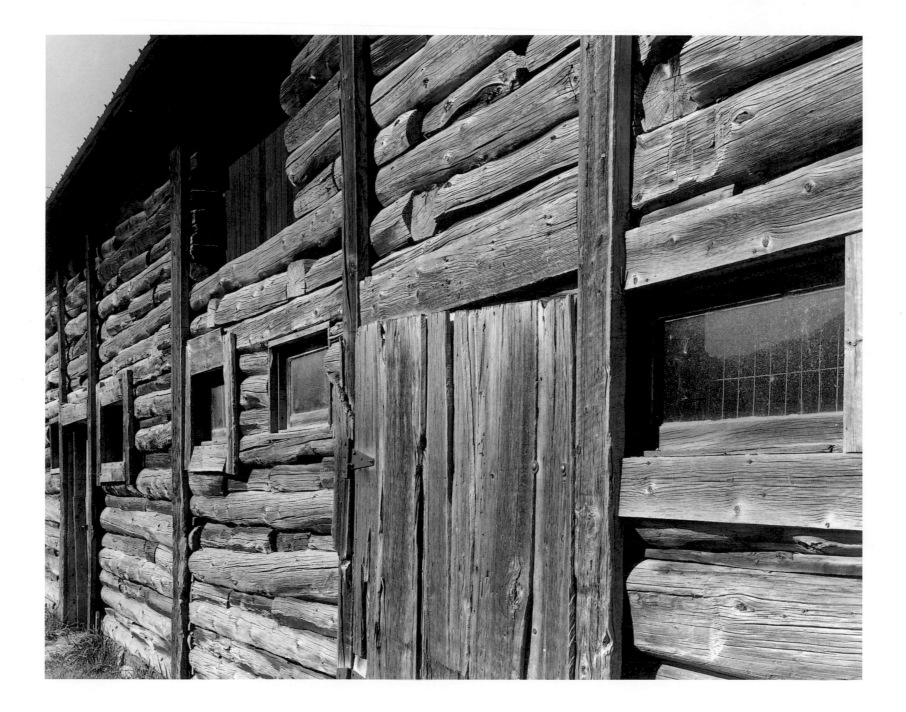

Plate 50

A Dutch Colonial Barn
Adams County, Washington
1900

In the West, barns with gambrel roofs appear in numbers second only to those of the gabled-plain style, and more than 90 percent of them qualify as Dutch colonials because of their slightly flared eaves. The gambrel roof allows for somewhat more loft space than the pitched-roof style (Plate 52), but our field studies suggest that its popularity was more a matter of taste than of practical intent. This barn was built by the immigrant Schrag family, relatives of the Gerings, whose life and times are described in Chapter 3. In external plan it measures 36 feet 6 inches by 49 feet 6 inches, and it is 36 feet tall from ground to ridge top.

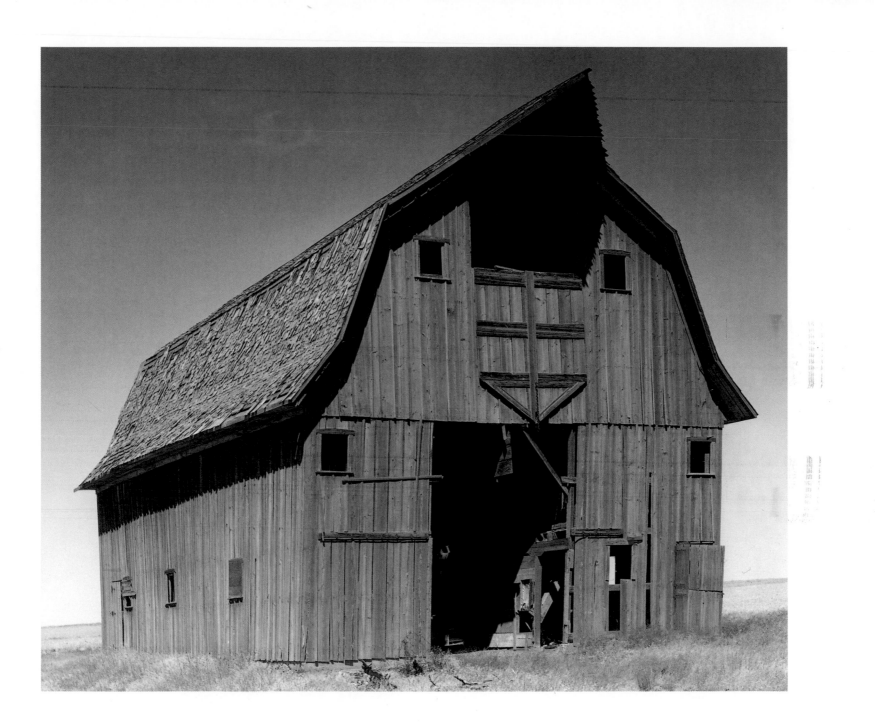

Plate 51

Haymow

Las Animas County, Colorado

1915

Even in those parts of the homestead West that had good cold-weather pastures, winter hay was, and is, required. Depending upon the region, either native grasses or domesticated species provided the necessary fodder, but with deteriorating climate and the depression of the 1930s, both of these sources quite literally dried up. This loft of a Dutch colonial barn held 50 tons of loose hay, enough to feed fifty head of beef cattle from December to May. Hay was pitched to cattle on the ground floor through open hatches that line both sides of this loft, whose dimensions are 36 by 70 feet. Floor to gable height is 20 feet.

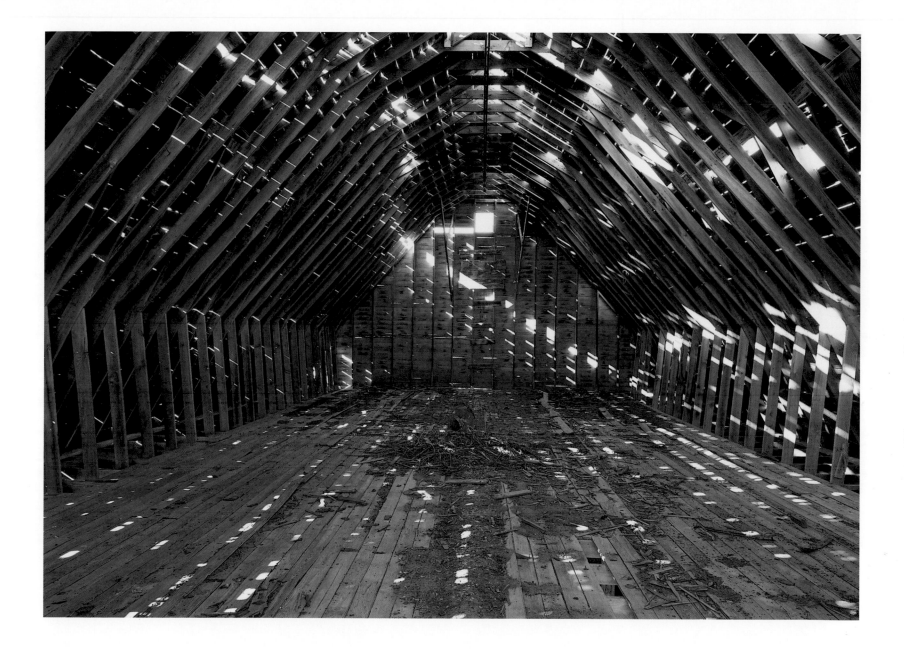

Plate 52

A Western Classic
Park County, Montana
1920

This homestead barn of a style I call the western classic is distinguished by its two wings for livestock (see Plate 53). In addition, it contains a central hayloft and central ground-floor storage space. The cupola was both decorative and a means of ventilation, which promoted drying of loose hay. Often, western classic barns are wider—front and back—than they are long. This example has an external width of 67 feet, but a length, along each side, of only 41 feet. Its height, ground surface to ridge, is 24 feet.

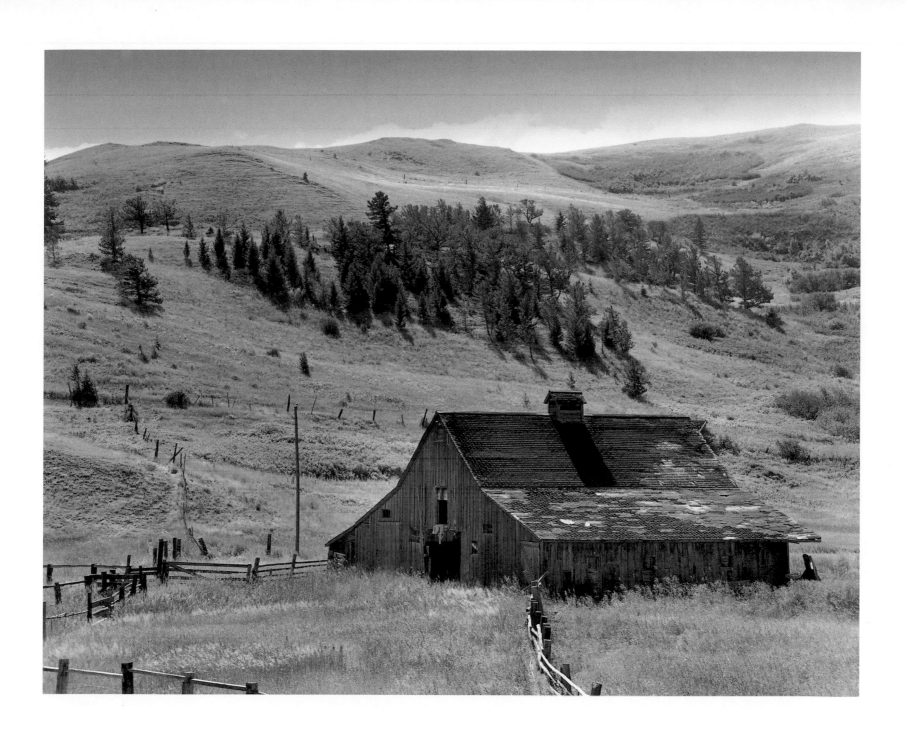

Plate 53

Western Classic Detail
Gallatin County, Montana
1903

The external horizontal dimensions of this big western classic barn are 63 by 73 feet, and from ground to ridge it is 31 feet, 6 inches tall. Its central part held 100 tons of loose hay, and as was typical, its two wings (see Plate 52) sheltered horses and cattle, respectively. This, the cattle wing, accommodated eight dairy cows in stanchions built between the five vertical log posts shown in this picture. The wall on the right, with its door opening on the central machine storage room, is 17 feet tall.

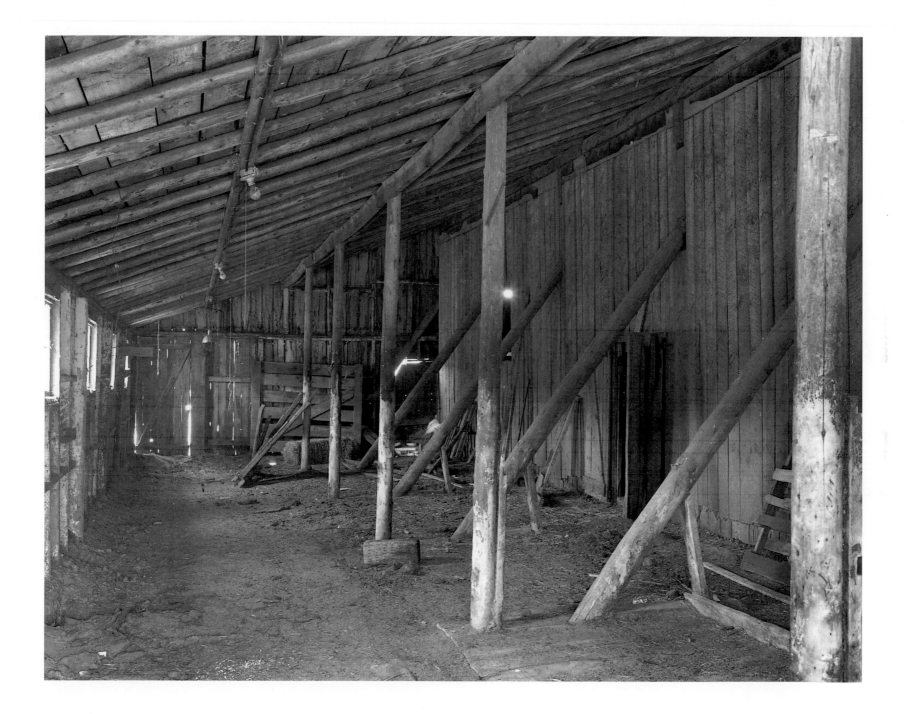

Plate 54

Arched Roof Style
Gooding County, Idaho
1900

Over most of the homestead West, arched roof barns are scattered rather uncommonly among other styles. We counted a total of 101, with 62 of these in Montana and Washington. All were large. The external dimensions of this example, 36 by 46 feet in plan, and 34 feet from ground to rooftop, are close to the average of those we measured. Some appear to have been homemade; others were built from drawings and materials supplied by midwestern construction firms.

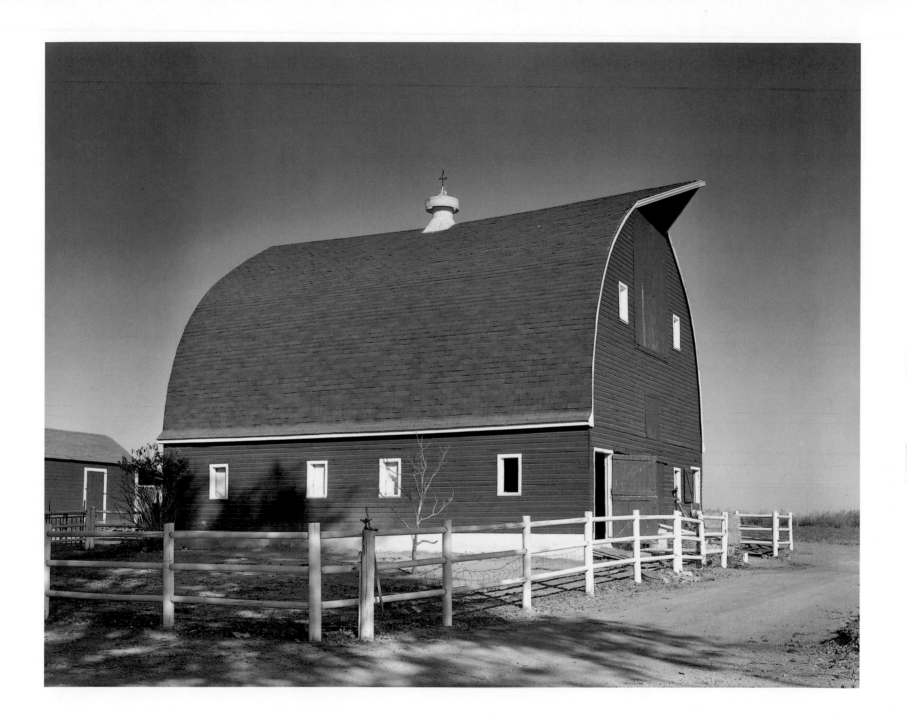

Plate 55

Ground Floor Detail
Park County, Montana
1999

As described in Chapter 3, in addition to housing livestock, the ground floors of the several standard barn styles served as storage space. Today, few surviving homestead barns shelter animals, but instead are commonly filled with a marvelous welter of discarded farm artifacts. In this picture of a Dutch colonial, most of the space between the camera and the far wall once contained horse stalls. Now, among its other artifacts, note the toothed blades of an old-time mowing machine, and on the post in the foreground an early-1930s hand-crank telephone that has a total height of 18 inches.

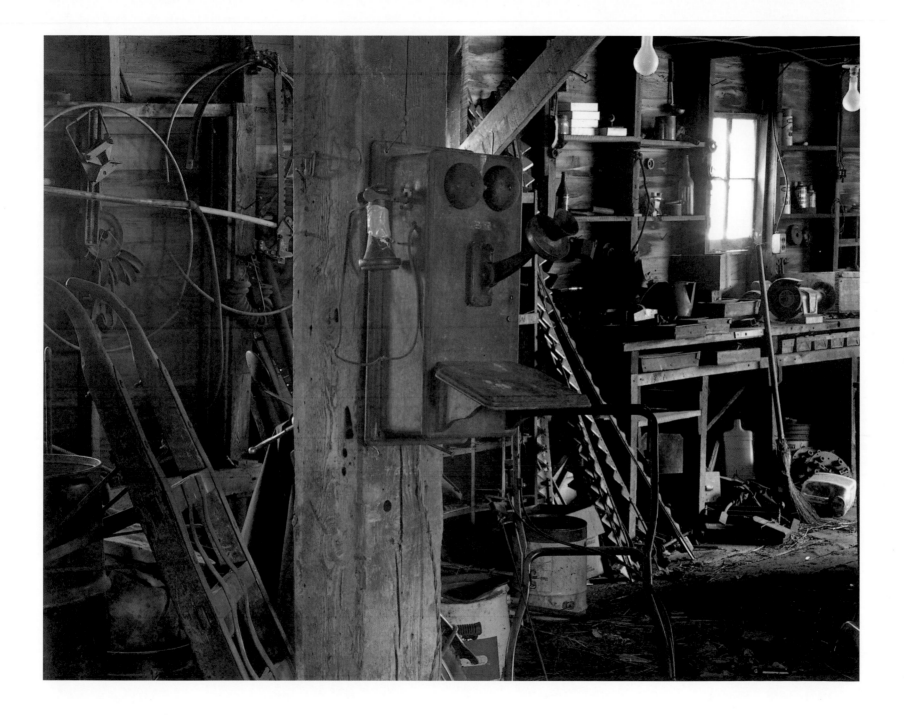

Plate 56

Beaver Slide
Deer Lodge County, Montana
1999

The beaver slide is among the more picturesque of surviving western homestead im-
plements. Today its use is restricted mainly to central and western Montana, where
some cattle ranchers still prefer to store their winter hay in old-fashioned stacks (one
of which appears here at far left). This example is built of more than 150 hand-hewn
pine poles or pole sections. Operated these days by a tractor rather than a team of
horses, it will accommodate up to a half-ton at one time, building a stack by tilting
the loose hay from its open frame. The ladder in its midsection is 14 feet tall.

Plate 57

Hay Derrick
Taos County, New Mexico
date unknown

Designed to pile loose hay in tall stacks, or to fill barn mows, a hay derrick belonged in practically every homestead inventory. This typical derrick, 20 feet tall, was fitted with a block and tackle attached to a grapple, which in turn was tripped with a trailing rope. With horses on the rope, a good derrick could lift, swing, and drop 450 pounds of loose hay at a time. Standing on a long-abandoned homestead in northernmost New Mexico, this derelict is made principally of hand-hewn logs.

Plate 58

Hay Wagon
Klickitat County, Washington
circa 1910

Distinguished by its flat bed and tilted front rack, the hay wagon was essential to practically every homestead farm. As the green hay was cut, it was left on the ground for a few days to dry. Then with an aptly named pitchfork it was pitched onto the wagon for transport to barn or stack. The length of this typical wagon bed is 15 feet. With its heavy axles and wheels fitted with steel tires, it was pulled by a two-horse team and had a payload of about 1 1/2 tons of loose hay.

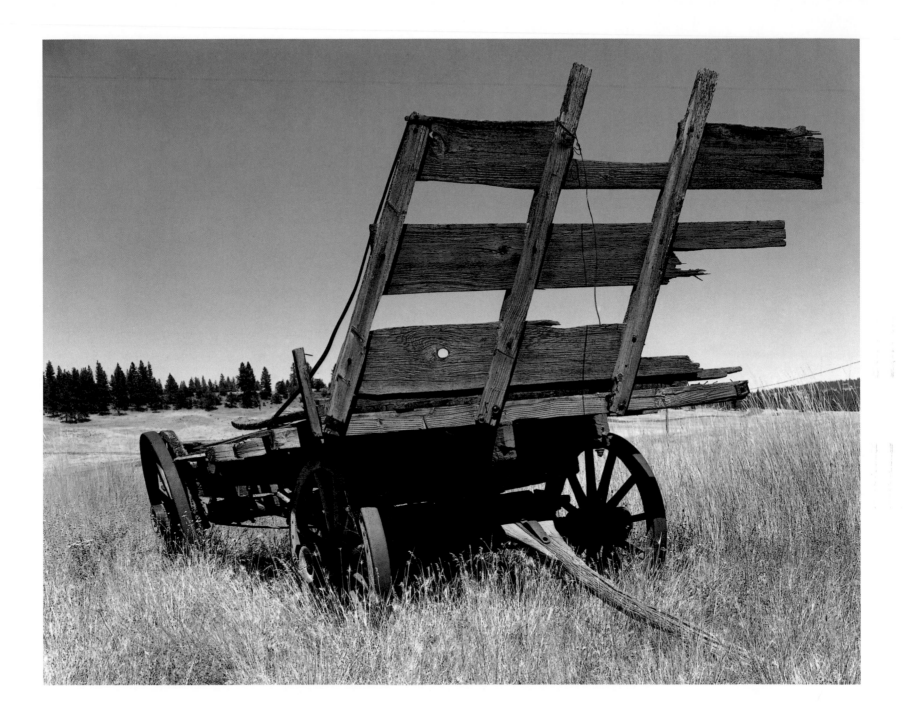

Plate 59

A Flume in the Sagebrush
Okanogan County, Washington
date unknown

A small percentage of big sage country homesteaders arrived early enough to settle on land that with much hard work could be irrigated artificially rather than dry-farmed. Here is what is left of an aqueduct—called a flume in the interior Northwest—that carried water to sagebrush farms from a diversion dam in the Okanogan River. Built of boulders, the dam reached out from the river's bank just far enough to divert the essential water into a head ditch. On its way down-country, the ditch water in these pine-board flumes was carried across gulches and around cliff faces. This pine-board example is 4 feet wide and 3 feet deep.

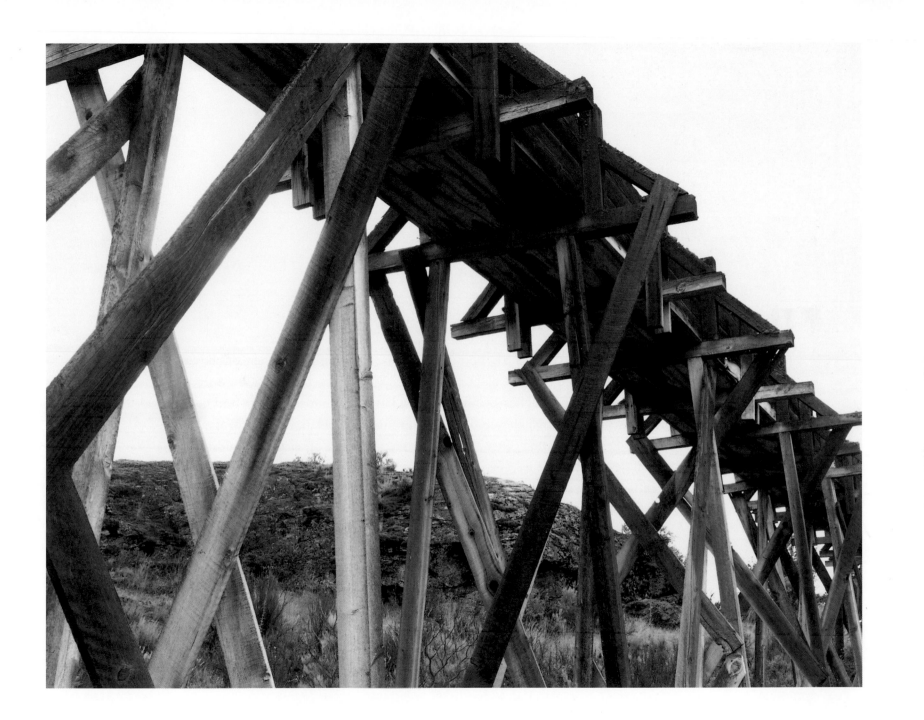

Plate 60

The Naches–Selah Project
Yakima County, Washington
1916

On big sage country rivers, early boulder-built diversion dams and their ditches and flumes were succeeded by more elaborate systems financed by the pooled resources of would-be farmers. The Naches–Selah Irrigation District, founded in 1916 and named for the Scottish town of Naches and the Swedish town of Selah, takes its water from the Naches River, irrigating more than 10,000 acres which otherwise would remain sagebrush desert. In this case, instead of homesteading, the incoming farmers bought their holdings from land developers. The section of original wood flume shown here is 5 feet tall and 9 feet wide.

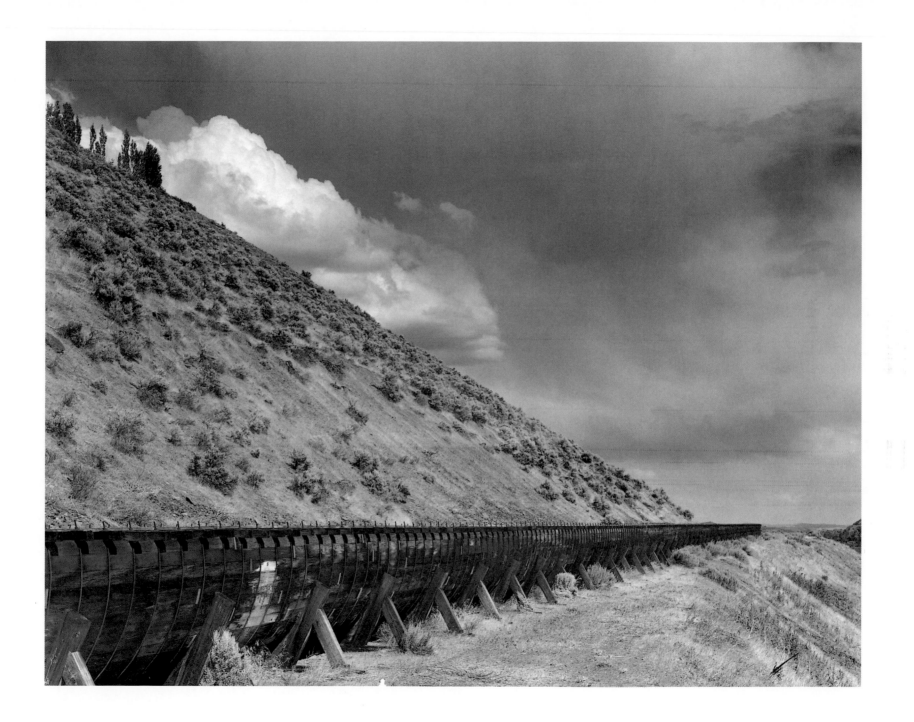

Plate 61

Log Wagon
Marion County, Oregon
circa 1895

These heavy axles and wheels survive in a homesteader's shed among the misty forests of western Oregon. Among western homestead lands, proving up in these dark woods was the most difficult work of all. First, the giant trees were felled with two-man crosscut saws. Then, their trunks were cut into short lengths which, with impressive expenditures of horse, mule, and manpower, were loaded and hauled away on stout, flatbed wagons. These efforts, although they left behind dozens and, on occasion, even hundreds of looming stumps, allowed for enough planting to meet the homestead requirement. Outside diameter of these heavy log wagon wheels is 41 inches.

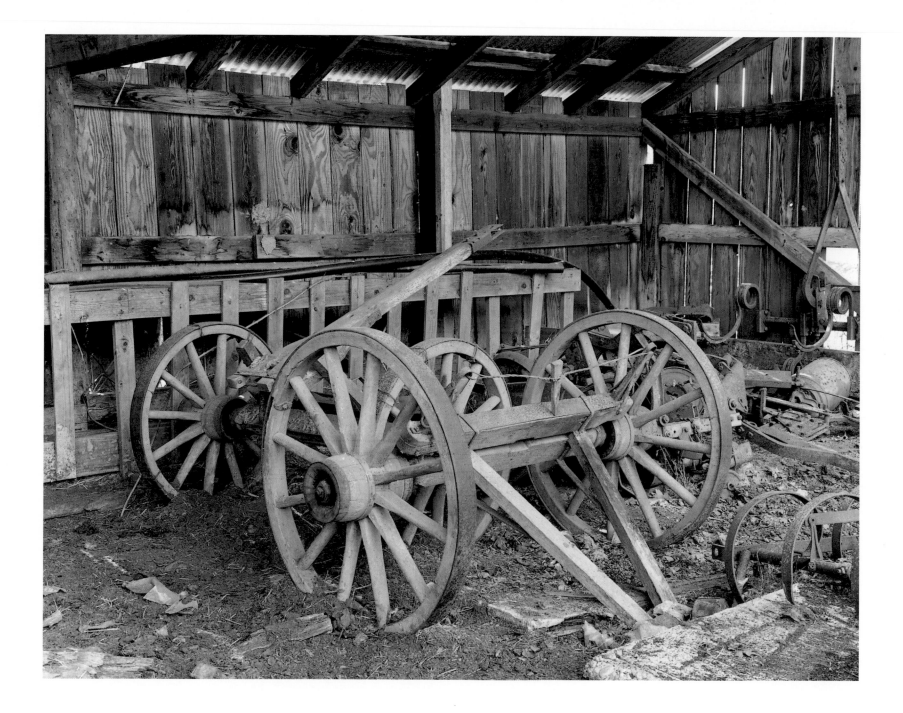

Plate 62

Store on the Springer Road
Colfax County, New Mexico
circa 1910

According to local lore, this three-room building served both as a dwelling and a
store on the old wagon road between the prairie towns of Clayton and Springer, an
overland distance of some 80 miles. While in other respects this building conforms
to the common hipped-roof homestead dwellings of eastern New Mexico and south-
eastern Colorado, it is distinguished by its fine thin limestone building blocks, and
by its curious but pleasing semi-dugout construction. At back, its floor lies 4 feet be-
low ground surface. External horizontal dimensions are 18 feet 6 inches by 32 feet,
and front height from ground to ridge is 10 feet.

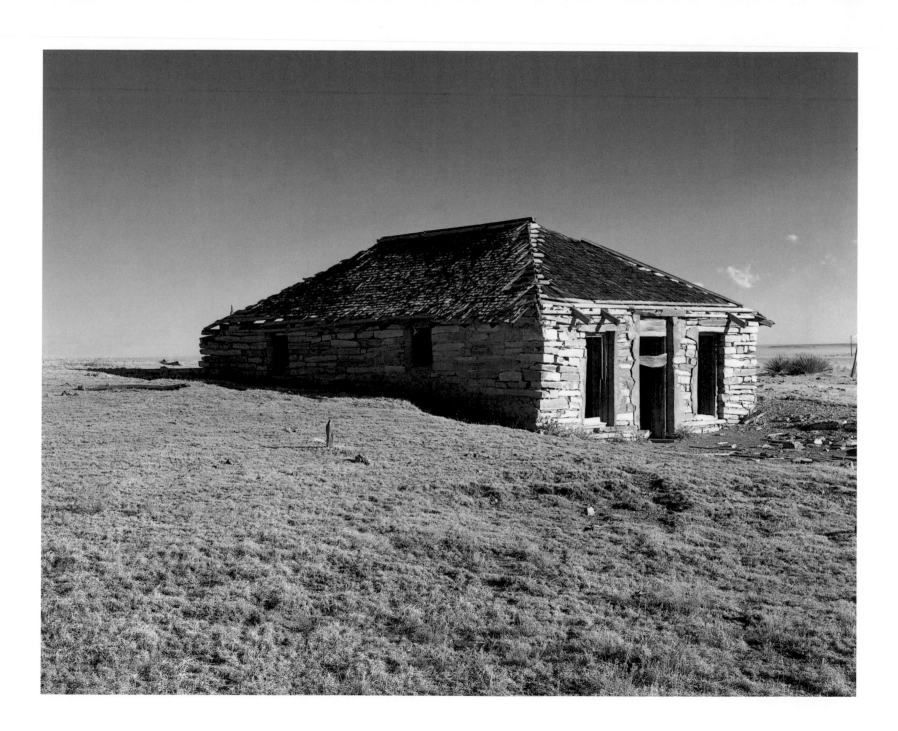

Plate 63

Hotel

Torrance County, New Mexico

1910

Invariably, when a homestead town had a railroad it had a hotel, typically a two-story building with rooms upstairs or on both floors, a small downstairs lobby, and sometimes a downstairs restaurant and saloon (see Campbell 1996, plate 5). This example of chiseled limestone blocks, in the tiny settlement of Duran, departs from the norm because nearly all of its first floor was an expansive mercantile establishment. According to the lettering across its front, the shop sold everything from furniture to fodder. Upstairs, a central hallway is lined on either side with a total of sixteen rooms, and contains in addition a lobby and kitchen area. The building is 30 feet tall, and in external plan measures 40 by 100 feet.

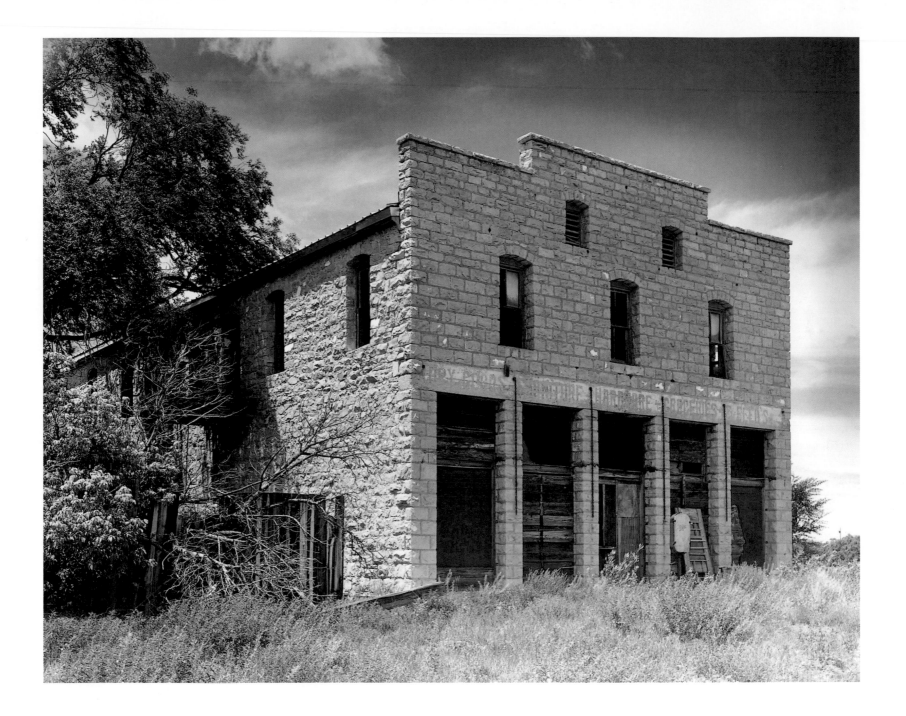

Plate 64

Jail House at Kim
Las Animas County, Colorado
date unknown

As was typical of western homestead towns, the Kim crime rate was low and serious crime was exceedingly rare—one murder in the past one hundred years, according to local historians. But there were the occasional fist-fighters and obnoxious drunks who got locked up overnight by the town marshal. This jailhouse is like hundreds of others in the homestead West. Made of poured concrete, its walls and roof are 6 inches thick, from ground to ridge it is 8 feet tall, its external plan dimensions are 12 by 16 feet, and it contains two cells. The inside dimensions of this back window are 17 by 31 inches.

Plate 65

U.S. Post Office
Union County, New Mexico
circa 1910

The success of this pinto bean farm is witnessed by this six-room homestead house with its dormer, veranda, and gambreled, Dutch colonial roof lines. While gambreled barns were numerous, and many prosperous towns contained houses of this style, Dutch colonial farmhouses were rarities, accounting for much less than 1 percent of western homestead house types. These are the shortgrass prairies of eastern New Mexico, and until annual precipitation became reduced radically in the 1930s, they supported dozens of homestead towns. As drought ruined Union County farming, this fine rarity served out its last days as both a dwelling and the Pasamonte Post Office. External plan dimensions are 34 by 40 feet; height from ground surface to ridge is 24 feet.

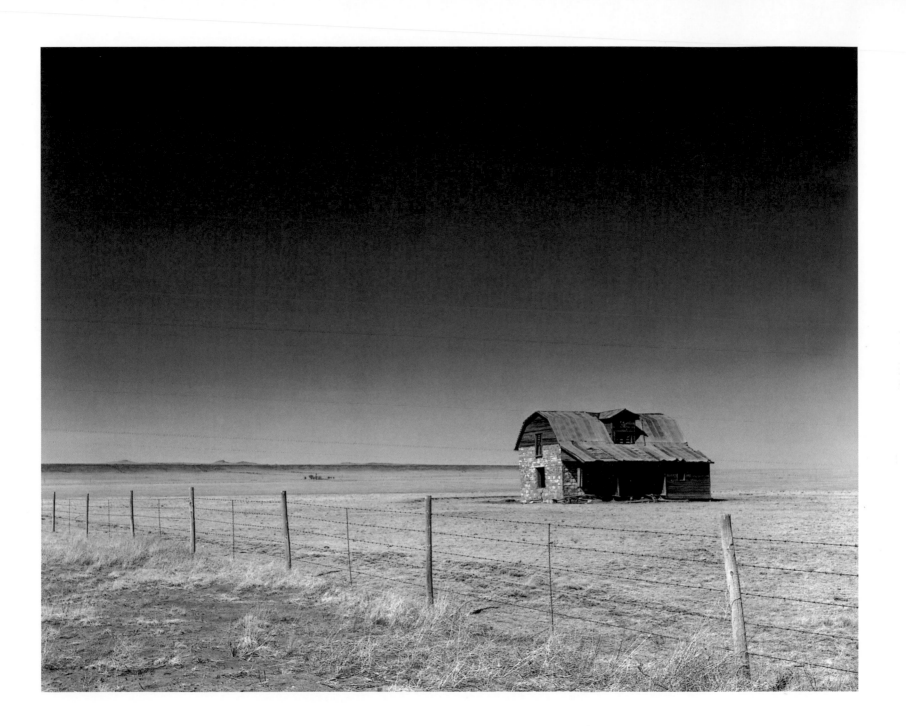

Plate 66

Grocery Store and Post Office
Quay County, New Mexico
circa 1907

Today, the homestead town of Hassell is occupied by one resident ranching family, a former church, a graveyard, and this important building. The life span of a regional western homesteading endeavor can be measured commonly by the longevity of its post office. The Hassell post office was established in 1907 and discontinued in 1948 (Pearce 1965, 69), dates which conform closely to the history of homesteading in Quay County. This store–post office is one of the few adobe brick buildings that survive on the homestead plains of New Mexico (see Plate 14). External plan dimensions are 23 by 24 feet, and its ridge stands 14 feet above ground surface.

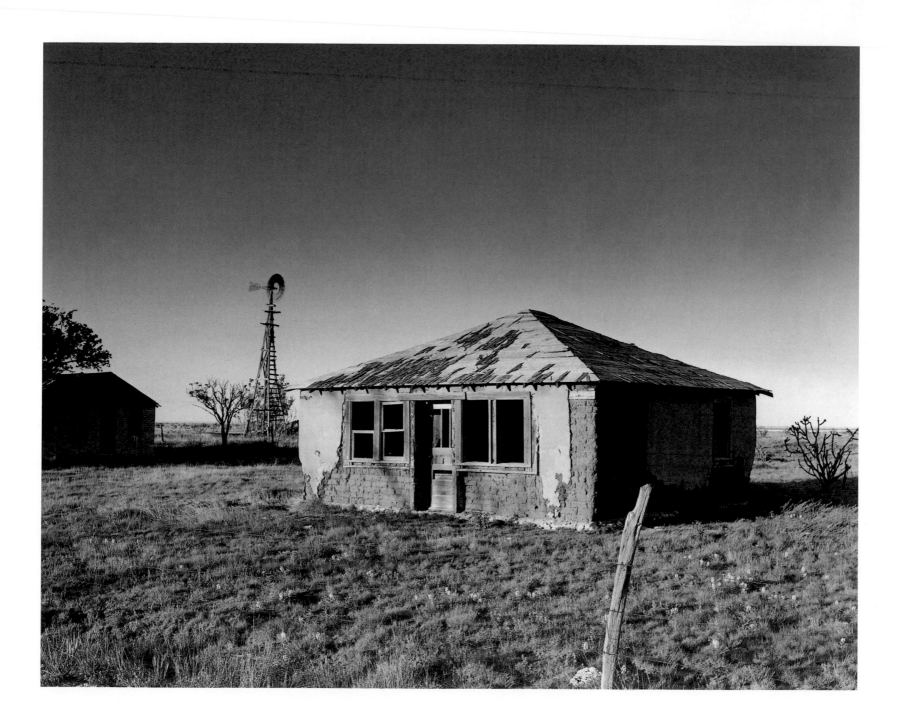

Plate 67

Anniston Cemetery
Quay County, New Mexico
1908

Graveyards and their headstones have instructive tales to tell. For historians and archaeologists they provide a wealth of otherwise irretrievable evidence relating to average life spans, occupations, and religious, ethnic, and social activities. This cemetery is the single remaining trace of the homestead settlement of Anniston. Its post office lasted only from 1909 to 1913 (Pearce 1965, 8), but its graveyard was used by homesteaders, then ranchers, for several succeeding decades. Inscriptions on about 12 percent of its surviving stones testify apparently to the ravages of the infamous flu epidemic of 1917–18.

Plate 68

Happy Valley
Colfax County, New Mexico
1997

Happy Valley, surrounded by elegant, long-dead volcanoes, covers about 200 square miles of shortgrass prairie. Even now, given a rare year of snow and rain, it can be as green and promising as any farmer could hope for, and in 1915 it seemed like a homesteader's dream come true. The nearest rail lines lay within a long day's wagon drive, and hundreds of homesteaders flocked in. Pinto (navy) beans, grown without artificial irrigation, were the cash crop, and for more than three decades Happy Valley was prosperous farmland. Now, after years of drought, it is home to a total of four cattle ranchers.

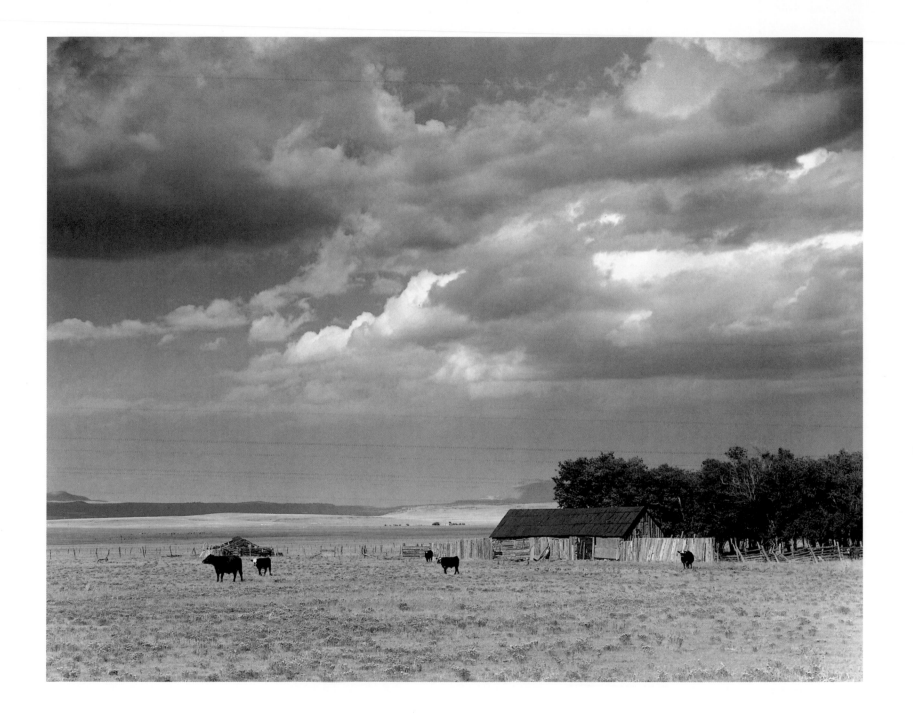

Plate 69

Saddles
Colfax County, New Mexico
circa 1935

To this day, in some out-of-the-way parts of the homestead West, deserted houses and barns contain possessions left behind by "gone-broke" farmers. In eastern Colorado and central and eastern New Mexico, prolonged drought continued to devastate thousands of farms until well into the 1950s. From those years, this writer remembers abandoned homestead houses containing made-up beds, books, lamps, china, and rocking chairs—all remaining just the way they were on the day the family gave up. These saddles, ruined now by time, mice, and a leaky barn loft, were left here in a bleak Dust Bowl summer.

Plate 70

A New Ford Truck
Baca County, Colorado
1934

The Dust Bowl calamity was caused only indirectly by plowing up the plains. It re-
sulted mainly from a climatic shift that would have turned the prairies into semi-
desert, plows or no plows. A variety of modern investigative techniques reveal that
episodes of severe drought have repeatedly laid waste to the western shortgrass prai-
ries over the past several thousand years. Nevertheless, it was the loose topsoil of
farms carried by the wind that turned the skies black at noon, covered fence rows to
the tops of their posts, and half buried your Ford V-8 during the 1930s Dust Bowl.
For many homesteaders, the natural disaster signaled that it was time to quit. Over-
all length of this truck is 18 feet.

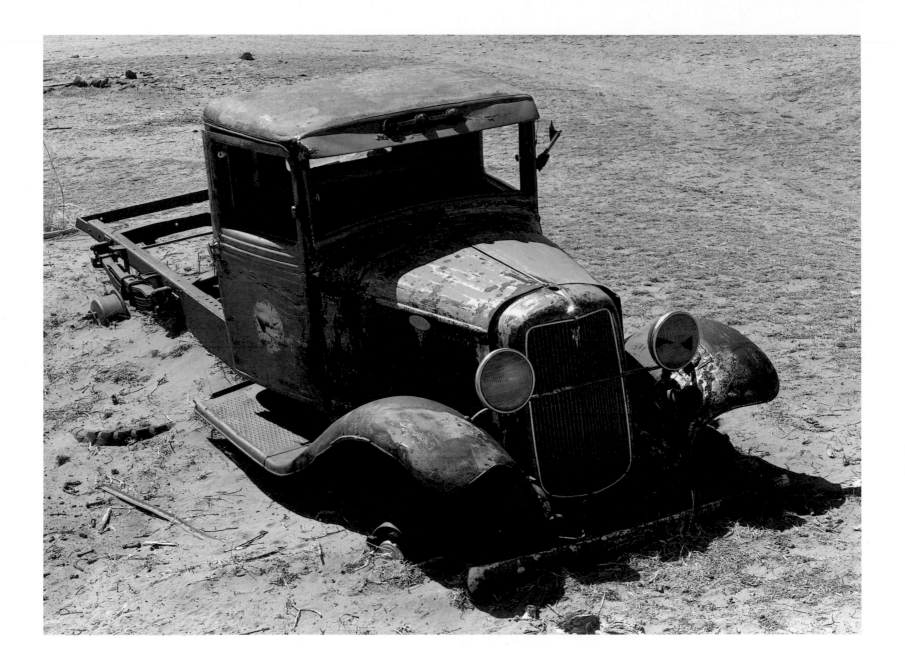

Of the larger homestead relics—houses, barns, and other structures—that survive today in various parts of the United States, a total of 377 have been placed on the National Register (as of April 21, 2000), 63 of which are located in the regions shown on the map that appears at the beginning of this volume (see page 10).

State	County	Site Name
Arizona	Coconino	The Homestead
		Pendley Homestead Historic District
	Maricopa	Jesus Miranda Homestead
California	Mariposa	Hodgdon Homestead Cabin
	Mendocino	Lovejoy Homestead
Colorado	Arapahoe	Gully Homestead
	Custer	Mingus Homestead
	Grand	E. C. Yust Homestead
	Jefferson	Hiwan Homestead
	Larimer	Enos Mills Homestead Cabin
		Homestead Meadows Discontiguous District
	Rio Grande	Keck Homestead

State	County	Site Name
Idaho	Valley	Matt N. Hil, Homestead Barn
		Thomas Jarvi Homestead
		John Korvola Homestead
		Charles Koski Homestead
		Gust Laituri Homestead
		Jacob and Herman Mahala Homestead
		Herman Ojala Homestead
		Matt Ruatsale Homestead
		Nickolai Wargelin Homestead
		Jacob Maki Homestead
		John G. Johnson (Rintakangas) Homestead
		John S. Johnson (Sampila) Homestead
Kansas	No listing for area shown on map	
Montana	Big Horn	Lee Homestead
	Blaine	Anna Scherlie Homestead Shack
	Cascade	Crocker–Jarvi Homestead
		Heikkila–Mattila Homestead
		Kraftenberg Homestead

State	County	Site Name	State	County	Site Name
Montana	Cascade *(continued)*	Lewis–Nevala Homestead	Oklahoma	No listing for area shown on map	
		Wargelin–Warila Homestead	Oregon	Deschutes	William T. E. Wilson Homestead
		Robert Vaughn Homestead			Charles Boyd Homestead Group
		Stone Homestead		Wasco	Gulick Homestead
	Flathead	McCarthy Homestead Cabin	South Dakota	Butte	Carl Friedrick Gartner Homestead
		J. K. Miller Homestead		Custer	Norman B. Streeter Homestead
		Charlie Schoenberger Homestead			Maria Bauer Homestead Ranch
		Anton Schoenberger Homestead		Perkins	Anna Carr Homestead
		Margaret McCarthy Homestead	Utah	No sites listed as of April 21, 2000	
		Johnnie Walsh Homestead	Washington	Chelan	Lucas Homestead
		William Raftery Homestead			Buckner Homestead Historic District
		Wurtz Homestead			Burbank Homestead Waterwheel
	Gallatin	Jesse R. Green Homestead		Jefferson	Saint's Rest Pioneer Cabin and Homestead House
	Sheridan	Aage and Kristine Larsen Homestead		San Juan	Krumdiack Homestead
Nebraska	Banner	C. C. Hampton Homestead		Whatcom	Hovander Homestead
	Sioux	Harold J. Cook Homestead Cabin	Wyoming	Sweetwater	Elinore Pruitt Stewart Homestead
Nevada	No sites listed as of April 21, 2000				Elinore and Clyde Stewart Homestead
New Mexico	Bernalillo	Juan Cristobal Armijo Homestead			
	Lincoln	Aguayo Family Homestead			
North Dakota	No listing for area shown on map				

Notes

Chapter 1

1. For a variety of facts and opinions regarding these agrarian adventurers, see Babb 1971, Jones-Eddy 1992, Limerick 1987, Micheaux 1994, Pratt 1993, Sherman 1983, and Smith 1971.

2. The term *growing season*, as applied to a particular location or region, and as reckoned by agronomists and climatologists, refers to the number of days between the last frost of spring and the first frost of autumn.

3. This writer had the good luck, beginning in his early childhood, to have known the Fontaines for twenty-five years.

4. In Campbell 1996 (9), I remarked that the number of western homesteaders peaked in about 1915. I now think the peak occurred three or four years earlier, based on recent field interviews and on state, county, regional, and local references (see Niobrara County Historical Society 1987, Cheney 1996, Cochrane 1984, Crook County Historical Society 1981, Daniels County Bicentennial Committee 1977, Forsyth 1989, Gossett 1979, Hatton 1977, Houghton 1986, Johnson and Johnson 1998, Pearce 1965, and Rostad 1994).

5. Over the past ten years it has been my privilege to know D. Ray Blakeley (see Acknowledgments), who is a journalist, radio commentator, and historian in Clayton, the Union County seat. Blakeley is the grandson of Moody and Suzie Lucille Cherry, and he has provided me with these details of the family history.

Chapter 2

1. As simple as they were, in the hands of the homesteaders such tools were used to create impressive works of practical art. Among others, we found a 20-foot watering trough hewn with artistic sophistication from a cottonwood log; a chicken coop enclosed with a latticework of whittled and smoothed willow withes; and a small, elegant adobe fireplace, in a small, elegant dugout (Plate 13).

2. While there was relatively little bloodshed, bullying of the homesteaders by cattlemen or their cowboys was hardly unheard of, and a variety of politically incorrect terms—applied by the latter to the former—became incorporated into the lexicon of the range. See Barker (1998) for examples, and note also that the title of Charles M. Russell's 1927 book, *Trails Plowed Under*, expresses quite succinctly the dismay of the "disenfranchised" cattlemen, who felt that the prairies belonged to them, even though they did not "own" them legally. Ironically, practically all of my cattle rancher informants (whose names in the Acknowledgments section far outnumber those of farmers) are direct descendants of western prairie homesteaders.

3. Some western homesteaders owned sidearms, including large-caliber pistols and revolvers (Barnes 1965, 144–78; Logan 1959). Among these was the famous Colt .45 Frontier Model, "the gun that won the West." Still—for good or bad—these were weapons of combat, and it took an extraordinarily good shot to kill game or varmints with a

sidearm. For that reason, the typical western homesteader did not own a sidearm, or if he did, only kept it "just in case."

4. The evolution of the different types of western homestead houses, as described here and in the following pages, may be observed in all of the several states examined, but is expressed most abundantly in Colorado and New Mexico. It is noteworthy that an earlier study by Karsmizki and Brownell (1983) found the same progression of types in south-central Montana.

5. In Campbell (1996, 14), I remarked that this simple gabled house "had its origins in the forests of northern Eurasia, perhaps in western Siberia or the Scandinavian Peninsula." It has since come to my attention that Theodore Roosevelt, the younger, in writing of his hunting adventures, observed that beside a river in Turkestan, there stood "three log huts. They were built much the same as the log cabins of our own West. Their roofs were covered with earth on which grass was growing. The rushing stream, the snowy mountains, the fir trees, and log cabins all made me feel as if I were in the Northern Rockies" (Roosevelt and Roosevelt 1926). So, perhaps I should have confined my remarks to simply "Eurasia."

Chapter 3

1. Numerous descendants of these two groups live today in Clackamas and Adams Counties, where they are known as the Old Mennonites and General Conference Mennonites, respectively. Most of them are college graduates. For details of the Gering family history, I am indebted to Joseph Gering's great-great-grandson, Gordon L. Gering, who is an Adams County wheat grower, a faithful member of his congregation, and a 1961 graduate of the University of Washington.

2. Over the past eighty years wheat of the type grown most commonly in Adams County and elsewhere in the West has brought farmers an average of about $3 per bushel (Department of Commerce 1995, 688). Adams County wheat land produces an average of 30 bushels per acre. Thus, at $3 per bushel, one square mile will bring $57,600 before expenses, and expenses are impressive. In planting and harvesting machines alone, today's typical Adams County wheat grower has an investment of upwards of $300,000.

3. For useful descriptions and histories of these and other barns, see Leffingwell (1997), Noble and Cleek (1995), Sloane (1976), and Stedman (1989). (N.B.: The nomenclature used by these authors often differs from my own.)

4. The saltbox lacks the long central open space of the other designs (see Plate 46), but it serves the identical purpose as the other four styles.

Chapter 4

1. For additional descriptions of the Dust Bowl, and of going broke, see Dick (1947), Worster (1979), and Wunder, Kaye, and Carestensen (1999).

2. In recent decades some of the old western homesteads have been listed on the National Register. For their locations and names, see the map (page 10) and the Appendix.

References Cited

Allen, Barbara. 1987. *Homesteading the High Desert*. Salt Lake City: University of Utah Press.

American State Papers: 8, Public Lands. Vols. 5, 6.

Babb, Sonora. 1971. *An Owl on Every Fence Post*. London: P. Davies.

Barker, Omar. 1998. Saying It Salty. *New Mexico Magazine*, March, 50–52.

Barnes, Frank C. 1965. *Cartridges of the World*. Chicago: Follett Publishing Co.

Boorstin, Daniel J. 1958. *The Americans: The Colonial Experience*. New York: Vintage Books.

Boyd, Julian, ed. 1950. *The Papers of Thomas Jefferson*. Vol. 12. Princeton, N.J.: Princeton University Press.

Brownell, Joan L., and Kenneth W. Karsmizki. 1990. *Historic Properties Cultural Resource Inventory for Three Candidate GWEN Sites in Roosevelt County, Montana*. Bozeman, Mont.: Western History Research.

Campbell, Hardy Webster. 1909. *Campbell's 1907 Soil Culture Manual*. Holdrege, Nebr.: Campbell Soil Culture Co.

Campbell, John Martin. 1996. *The Prairie Schoolhouse*. Albuquerque: University of New Mexico Press.

———. 1997a. *Few and Far Between: Moments in the North American Desert*. Santa Fe: Museum of New Mexico Press.

———. 1997b. Homesteaders Stake Odds on High Plains. *New Mexico Magazine*. March, 34–41.

Cheney, Roberta Carkeek. 1996. *Names on the Face of Montana*. Missoula, Mont.: Mountain Press.

Cochrane, Willard W. 1984. *The Development of American Agriculture: A Historical Analysis*. Minneapolis: University of Minnesota Press.

Continental Congress. 1774–89. *Journals of the Continental Congress, 1774–1789*. Edited by Worthington C. Ford et al. 34 vols. Washington, D.C., 1904–37.

Cotroneo, Ross. 1987. Northern Pacific Railway's Land-Grant Sales Policies: Selling Land on the Montana Plains, 1905–1915. *Montana: The Magazine of Western History*. May, 40–49.

Crook County Historical Society. 1981. *Pioneers Of Crook County*. Pierre, S. Dak.: State Publishing Co.

Daniels County Bicentennial Committee. 1977. *Daniels County History*. Great Falls, Mont.: Blue Print and Letter Co.

Dick, Everett. 1947. *Life in the West Before the Sod-house Frontier*. Lincoln, Nebr.: Prairie Press.

Donaldson, Thomas. 1970. *The Public Domain: Its History, with Statistics/Revision and Addenda*. New York: Johnson Reprint Corp.

Ferguson, Denzel, and Nancy Ferguson. 1978. *Oregon's Great Basin Country*. Bend, Ore.: Maverick Publications.

Fleck, John. 1997. Drought Reigns in N.M. History. *Albuquerque Journal*, May 27, pp. A1, A8.

Forsyth, John, ed. 1989. *Tracks: In the Tracks of the Homesteaders*.

Vol. 1. A Project of the Sophomore English Class, Wilsall High School, Wilsall, Mont.

Gates, Paul W. 1979. *History of Public Land Law Development.* New York: Arno Press.

Gossett, Gretta Petersen. 1979. *Beyond the Bend: A History of the Nile Valley in Washington State.* Fairfield, Wash.: Ye Galleon Press.

Hamburg, James F. 1975. Railroad and the Settlement of South Dakota During the Great Dakota Boom, 1878–1887. *South Dakota History* 5, no. 2: 165–78.

Hargreaves, Mary W. M. 1957. *Dry Farming in the Northern Great Plains, 1900–1925.* Cambridge, Mass.: Harvard University Press.

———. 1993. *Dry Farming in the Northern Great Plains: Years Of Readjustment, 1920–1990.* Lawrence: University Press of Kansas.

Hatton, Raymond R. 1977. *High Desert of Central Oregon.* Portland, Ore.: Binford and Mort.

Hibbard, Benjamin. 1965. *A History of Public Land Policies.* Madison: University of Wisconsin Press.

Houghton, Samuel G. 1986. *A Trace of Desert Waters: The Great Basin Story.* Salt Lake City: Howe Brothers.

Iseminger, Gordon L. 1981. Land and Emigration: A Northern Pacific Railroad Company Newspaper. *North Dakota Quarterly* 49, no. 3: 71–92.

Johnson, Vernell, and Louise Johnson. 1998. *South Dakota: Every Town on the Map and More: A Pictorial History.* Marceline, Mo.: Heritage House Publishing.

Jones-Eddy, Julie. 1992. *Homesteading Women: An Oral History of Colorado, 1890–1950.* New York: Maxwell MacMillan International.

Karsmizki, Kenneth W. 1993. Surveying Montana's Public Domain: The First Step in the Land Patenting Process. Bozeman, Montana. Unpublished manuscript.

———. 1994. The Granary of Montana: Northern Pacific Railroad Land and the Gallatin Valley. Bozeman, Montana. Unpublished manuscript.

Karsmizki, Kenneth W., and Joan Louise Brownell. 1983. *Gallatin Valley Homestead Survey [site data].* 7 vols. Bozeman: Museum of the Rockies, Montana State University.

Leffingwell, Randy. 1997. *The American Barn.* Osceola, Wisc.: MBI Publishing Co.

Limerick, Patricia Nelson. 1987. *The Legacy of Conquest: The Unbroken Past of the American West.* New York: W. W. Norton.

Lince, Robert S. 1984. *The Selah Story: History of the Selah, East Selah, and Wenas Valley in Yakima County, Washington.* Selah, Wash.: Selah Valley Optimist Printing.

Lindgren, Elaine H. 1991. *Land in Her Own Name: Women as Homesteaders in North Dakota.* Fargo: North Dakota Institute for Regional Studies.

Linthicum, Leslie, and Richard Pipes. 1996. N.M.'s Harvest of Hardships. *Albuquerque Journal,* May 19, pp. A1, A10.

Little, William. 1933. *The Oxford English Dictionary.* 2 vols. Oxford: Clarendon Press.

Logan, Herschel C. 1959. *Cartridges: A Pictorial Digest of Small Arms Ammunition.* New York: Bonanza Books.

Micheaux, Oscar. 1994. *The Homesteader.* Lincoln: University of Nebraska Press.

Muhn, James. 1993. Women and the Homestead Act: Land Department Administration of a Perplexing Question. Paper presented at the Annual Western History Conference, October 13–16, Tulsa, Oklahoma.

Muhn, James, and Hanson R. Stuart. 1988. *See* U.S. Department of the Interior. Bureau of Land Management.

Myres, Sandra L. 1982. *Westering Women and the Frontier Experience, 1800–1915.* Albuquerque: University of New Mexico Press.

Niobrara County Historical Society. 1987. *Our Heritage: Niobrarans and Neighbors.* Lusk, Wyo.: Niobrara County Historical Society.

Noble, Allen G., and Richard K. Cleek. 1995. *The Old Barn Book: A Field Guide to North American Barns and Other Farm Structures.* New Brunswick, N.J.: Rutgers University Press.

Pearce, T. M., ed. 1965. *New Mexico Place Names: A Geographical Dictionary.* Albuquerque: University of New Mexico Press.

Powell, John Wesley. 1878. *See* U.S. House. 1878.

Pratt, Alice Day. 1993. *A Homesteader's Portfolio.* Corvallis: Oregon State University Press.

Primm, James Neal. 1998. *Lion of the Valley*. St. Louis: Missouri Historical Society Press.

Robbins, Roy M. 1942. *Our Landed Heritage: The Public Domain, 1776–1936*. Princeton, N.J.: Princeton University Press.

Ronda, James P., ed. 1997. *Thomas Jefferson and the Changing West: From Conquest to Conservation*. Albuquerque: University of New Mexico Press; St Louis: Missouri Historical Society Press.

Roosevelt, Theodore, and Kermit Roosevelt. 1926. *East of the Sun and West of the Moon*. New York: Charles Scribner's Sons.

Rosenfeld, Rachael Ann. 1985. *Farm Women: Work, Farm, and the Family in the United States*. Chapel Hill: University of North Carolina Press.

Rostad, Lee. 1994. *Mountains of Gold, Hills of Grass: A History of Meagher County*. Martinsdale, Mont.: Bozeman Fork Publishing.

Russell, Charles M. 1927. *Trails Plowed Under*. Garden City, N.J.: Doubleday-Page.

Schroeder, Joseph J., Jr., ed. 1971. *1908 Sears, Roebuck Catalogue: A Treasured Replica from the Archives of History*. Northfield, Ill.: Digest Books.

Sherman, William C. 1983. *Prairie Mosaic: An Ethnic Atlas of Rural North Dakota*. Fargo: North Dakota Institute For Regional Studies.

Sloane, Eric. 1976. An Age of Barns. In *An Age of Barns*. Washington, D.C.: American Museum of Natural History.

Smith, Henry Nash. 1971. *Virgin Land: The American West as Symbol and Myth*. Cambridge, Mass: Harvard University Press.

Statutes at Large of the United States of America, 1789–1873. 17 vols. Washington, D.C., 1850–73.

Stedman, Myrtle. 1989. *Rural Architecture of Northern New Mexico and Southern Colorado*. Santa Fe, N.M.: Sunstone Press.

Taugher, Mark. 1966. Drought Looms in New Mexico. *The Albuquerque Journal*, April 14, pp. A1–2.

U.S. Congress. *Congressional Globe*. 1841. 26th Cong., 2d sess., 9: 130–32. Washington, D.C.: Blair and Rives, year??.

———. *Register of Debates*. 1826. 19th Cong., 1st sess., 2, pt. 1: 720–53. Washington, D.C.: Gales & Seaton, year??.

———. House. 1878. *Report on the Lands of the Arid Region of the United States*, by John Wesley Powell. 45th Cong., 2d sess. H. Doc. 73. Serial 1805.

———. House. 1959. Committee on Interior and Insular Affairs. *Reclamation—Accomplishments and Contributions*. 86th Cong., 1st sess. Committee Print 1.

U.S. Department of Commerce. 1995. *Statistical Abstract of the United States*, 115th ed. Washington, D.C.: Government Printing Office.

U.S. Department of the Interior. Bureau of Land Management. 1988. *Opportunity and Challenge: The Story of the BLM*, by James Muhn and Hanson R. Stuart. Washington, D.C.: Government Printing Office.

White, Richard. 1991. *"It's Your Misfortune and None of My Own": A History of the American West*. Norman: University of Oklahoma Press.

Worster, Donald. 1979. *Dust Bowl: The Southern Plains in the 1930s*. New York: Oxford University Press.

Wunder, John R., Frances W. Kaye, and Vernon Carestensen, eds. 1999. *Americans View Their Dust Bowl Experience*. Niwot: University Press of Colorado.